The Right Light

Photographing Children and Families Using Natural Light

■ Krista Smith

AMHERST MEDIA, INC. ■ BUFFALO, NY

About the Author

Krista Smith is the owner of Salty Kisses Photography, a natural-light photography company based in Florida. She studied Fine Arts at Brevard College in Brevard, North Carolina—and while she primarily photographs families and children, she has worked extensively with child modeling agencies throughout Florida. Her work has been featured in *Where to Retire, Southern Child Magazine, Coastal Kids Magazine,* and several books in the *500 Poses* series by Michelle Perkins (Amherst Media®). Krista prides herself on capturing images that are natural, authentic, and joyful—with all the energy and emotion of real life.

Copyright © 2014 by Krista Smith.
All rights reserved.
All photographs by the author unless otherwise noted.

Published by:
Amherst Media, Inc.
P.O. Box 586
Buffalo, N.Y. 14226
Fax: 716-874-4508
www.AmherstMedia.com

Publisher: Craig Alesse
Senior Editor/Production Manager: Michelle Perkins
Associate Editor: Barbara A. Lynch-Johnt
Associate Publisher: Kate Neaverth
Editorial Assistance from: Carey A. Miller, Sally Jarzab, John S. Loder
Business Manager: Adam Richards
Warehouse and Fulfillment Manager: Roger Singo

ISBN-13: 978-1-60895-693-7
Library of Congress Control Number: 2013952494
10 9 8 7 6 5 4 3 2 1

Check out Amherst Media's blogs at: http://portrait-photographer.blogspot.com/
http://weddingphotographer-amherstmedia.blogspot.com/

Contents

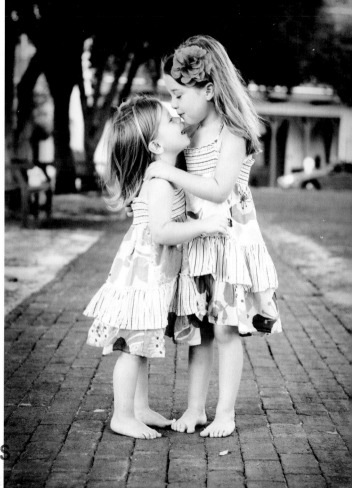

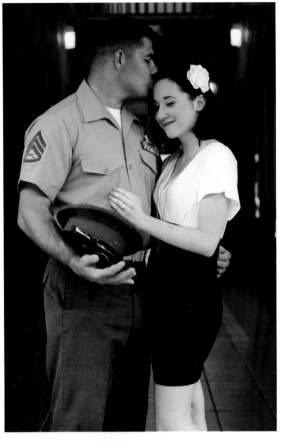

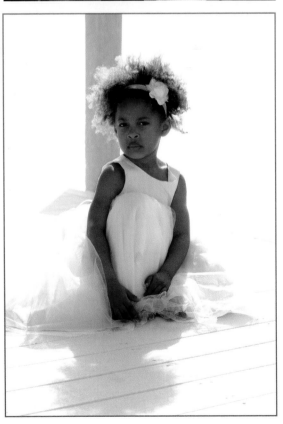

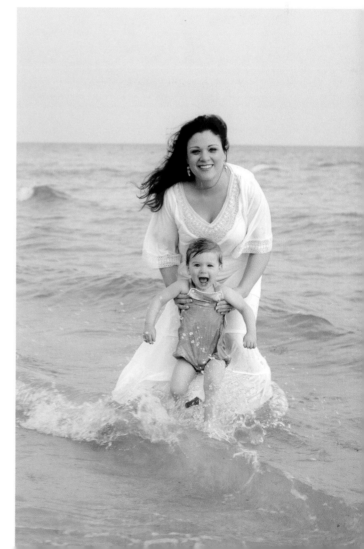

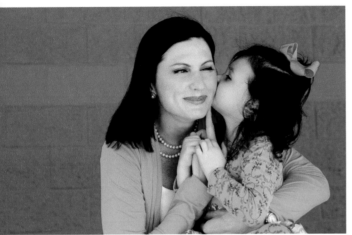

7. Posing to Flatter 91

Acknowledgements

A huge thank-you to my amazing husband Reed for supporting me as I learned and for not being afraid to critique me when I asked for it. I am so thankful for my three wonderful kids Carson, Trevor, and Addie Claire for allowing me to practice new lighting techniques on them long after they were tired of posing, and for providing endless creative inspiration and love. Thanks for forgiving the wacky dinners that sometimes get thrown together and pulling over on the side of the road so I can check lighting in the strangest places. I could not love other families the way I do without experiencing the amazing love within our own family. Thanks to my "sister" Darcy, who babysat my crew often without notice and kept me from pulling my hair out.

Thank you to my new friend Michelle Perkins for all her amazing help and to the people at Amherst Media for allowing me to share my experiences in photography. I am giddy with excitement!

Finally, big heartfelt thanks to all the families who allowed me to document such precious moments in their lives, and to all of my sweet friends for supporting me any time I needed it. I've been so blessed.

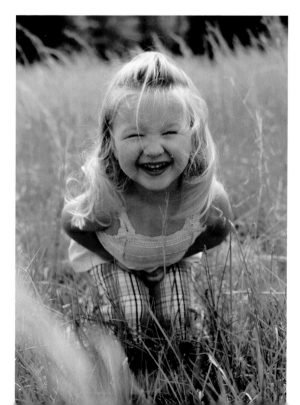

Introduction

I have always loved photographs. My baby album is full of Polaroids of my childhood, 4x5-inch rectangles of pea-smeared chubby cheeks and my best friend Laura and me on my beloved blue-and-white striped metal swing set or in her backyard pool. I was always fascinated by these fragile mementos that would develop right in front of my eyes. I thought it was pure magic.

Even after my parents switched to a sturdy little 35mm camera and the rounded-edge prints that were in style at the time, I loved looking at pictures of everyone I knew: grandparents, aunts and uncles, cousins, friends I loved, and the candid class pictures my mom dutifully took

> "I realized that the traditional portraits I was paying other people for weren't exactly what I wanted on my own walls."

as the classroom mother. I kept a box of my favorite images under my bed and pulled them out so often the edges began to show white where I had touched them.

I got my own camera at thirteen and filled roll after roll of film with group shots of friends, silly images of sleep-overs, shots of my room every time I rearranged it—nothing was safe. My very best friend and I became pen pals after I moved away and we took pictures of things we bought at the mall so that we could share our finds and stay close. I filled up album after album with hiking trips, waterfalls, parties, and fun modeling shots of everyone I knew.

The Road to Pro

Art and photography courses in college helped me learn how to shoot properly, develop film, and post-process my images, but I still wasn't ready to make it a career. After dabbling in creative jobs for a few years and taking countless rolls (and then memory cards) full of images of my

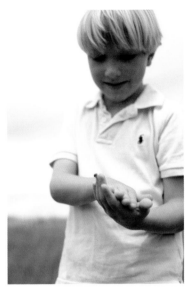

I-1. My big-hearted son Trevor sweetly allowed a ladybug to walk on his hand.

f/2, ¹/₄₀₀₀ second, ISO 200

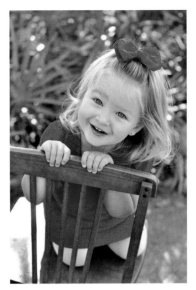

I-2. Feisty Addie Claire gave me her best cheese face in her Christmas dress on an antique chair that belonged to her grandfather.

f/4, ¹/₂₀₀ second, ISO 200

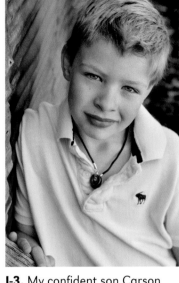

I-3. My confident son Carson posed for headshots next to a colorful tin wall.

f/5, ¹/₁₂₅ second, ISO 400

own little family, I realized that the traditional portraits I was paying other people for weren't exactly what I wanted on my own walls. At that time, portraits were still mostly traditional, done in studios on plain paper or printed background scenes; even with fun props like cars and huge numbers to sit on, they felt stiff and formal.

These images didn't reflect the everyday beauty of my children when the sun hit their blond hair and made it glow, the victorious twinkle in their eyes as they climbed up a tall ladder, or the thrill on their faces as their dad tossed them in the air. I thought to myself, "That's when they are their most authentic, their most beautiful."

Naturally, I will always treasure the solemn faces or cheesy smiles from their formal por-

traits because they are my babies. But if I *really* want to remember what they looked like, I turn back to the candid images I shot of their glee as they came down a really big slide and the intense concentration in their faces as they held a ladybug for the first time. When I realized this, something clicked inside: I wanted to capture these moments for other families, as well—to professionally and beautifully and authentically showcase the natural bonds of a loving family.

Available Light Only

I read everything I could get my hands on about photography, starting a business, maintaining a business, lighting, and posing, and decided I would focus primarily on location shoots and learn how to use available light to the best of my

ability so that I could allow my clients to roam a playground freely, run on the beach, and splash in the water as they pleased and not be tethered to certain spots with extra lighting gear. I am drawn to the idea that there is pure beauty in the natural light of a window, the hazy glow of dawn, and the lovely heat of a sunset. While I love the magic of off-camera flash and dramatic external lighting (and use it as needed), I find it fulfilling to create light, airy, flattering portraits with the light already provided from overhead: the sun.

Naturally, my preferences reflect what works best for *me* and *my business*. They are certainly not the only way to go about the business of portrait photography—they are merely what I have found works for me, what I enjoy shooting, and what I find aesthetically the most pleasing. I hope you enjoy them, too!

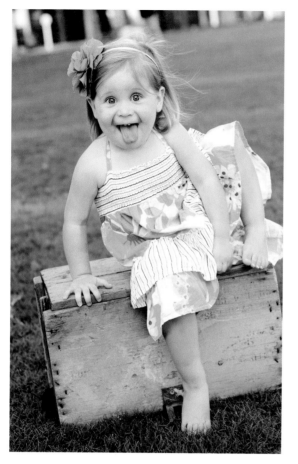

I-4 *(left)*. This is a perfect example of my kind of portraiture: plenty of light and color—and a pose with some serious individuality thanks to this adorable girl.

f/3.5, ¹/₁₂₅ second, ISO 250

I-5 *(below)*. How much more fun can you have on the beach during a portrait session? These cousins were a blast to photograph and had some amazing jumping skills.

f/5.6, ¹/₈₀₀ second, ISO 800

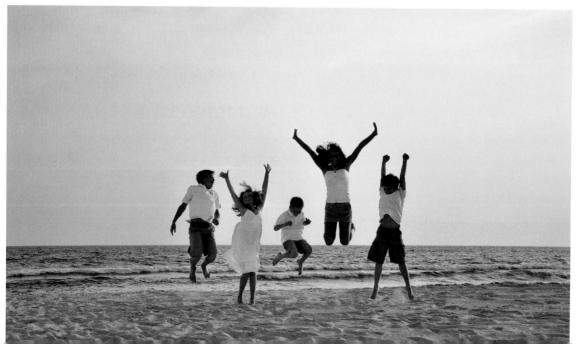

1. What You Need

LEARNING OBJECTIVES

Evaluate camera and lens features for available light portraits ◈
Select useful accessories for location portrait sessions ◈
Choose lighting tools for enhanced results with available light ◈

Just like every painter needs quality brushes and paints, photographers need quality equipment in order to create a masterpiece—but you don't have to purchase every toy on the market to make good images. Every photographer has their own personal favorites, but this list will get you started.

Camera

You want a good quality camera body with enough megapixels to cover the print sizes you will be aiming for. You also want a large enough sensor for your needs, and fun goodies like sensor stabilization, and an LCD viewing screen with Live View for those situations when you can't look through the viewfinder to get your shot. Whatever camera you choose, remember that freshly charged batteries (or a spare camera battery) are a must.

QUICK TIP > Make sure you are using the best batteries for your camera by consulting your manual or Google for reviews.

▦ Sensor Stabilization
A type of image stabilization that moves the image sensor to compensate for camera movement and help attain a sharp image.

▦ Live View
Mode in which the camera's reflex mirror is in the up position, blocking the normal viewfinder and allowing you to compose the image on the camera's LCD screen.

Lenses

Zoom *vs.* Prime. You'll have to decide whether you want a zoom or a prime lens, or some of each. Zoom lenses are great because they cover a wide range of focal lengths, which is useful when you are swapping back and forth between distances or want to

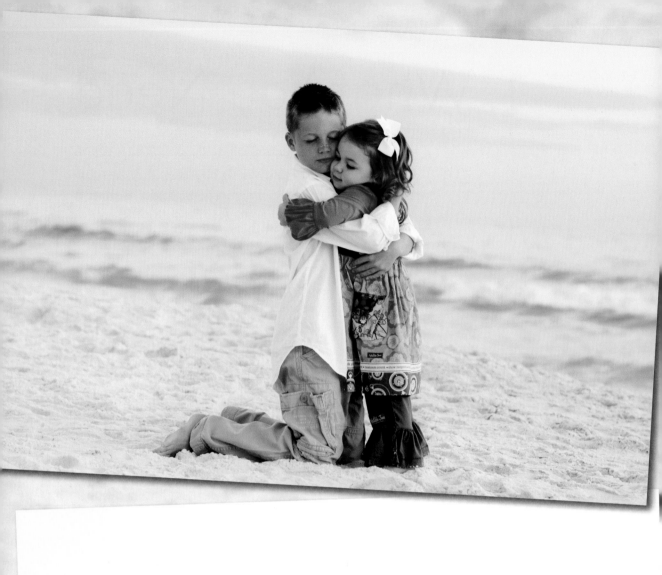
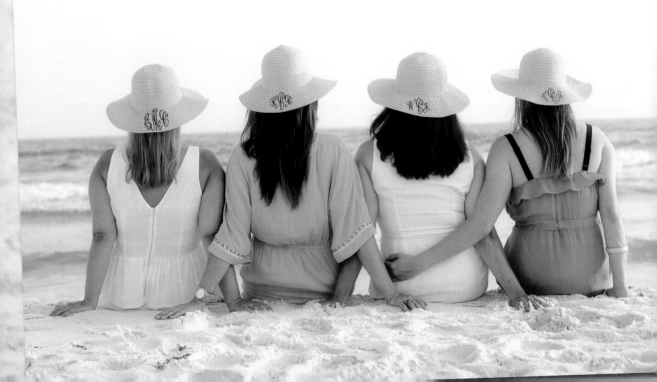

1-1 *(facing page, top)*. A loving big brother gave his little sister a sweet hug in front of a beautiful sky—an image any mother would love.

f/3.5, ¹/₁₆₀ second, ISO 500

1-2 *(facing page, bottom)*. This group of sisters and their mom were united by their pose. The repetition of their arms, outfit colors, and hats is aesthetically pleasing. The arm of the girl on the end kept the image from being boring.

f/4.5, ¹/₅₀₀ second, ISO 125

put a little more room between yourself and your model. However, they are often heavier than fixed focal-length lenses (prime lenses). With zoom lenses, you can be a bit more stationary and adjust your image with a twist of the lens. With prime lenses, you have to "zoom with your feet," physically changing your distance to the subject for a wider or tighter view. This means you typically need a bit more room around your model in order to move and get the image you want. I dearly love primes, but this is a personal preference. You'll quickly figure out which works best for you.

Focusing, Stabilization, and Speed. You want autofocus and the ability to change to manual focus. Image stabilization is extremely nice to have but is a personal preference. Quiet lenses are often important, so as not to disturb your model (sleeping babies, skittish wildlife, etc.).

You also want *speed*. You need a wide maximum aperture, at least f/4 or f/5.6. If the maximum aperture is any smaller (like f/8), you will have trouble getting your shutter speed down to a reasonable setting to freeze movement and allow for handholding. More expensive lenses

usually go down to f/2.8, letting you shoot at faster shutter speeds and get great, creamy bokeh in your background. (We'll get into more detail on lens settings in chapter 2.)

My Suggestions. I suggest getting at least one fast prime lens, such as a 35mm, 50mm, or

Do Your Homework

Check reviews of the lenses before you buy—let other people's experiences help you make your decision. Not all lenses are created equal, but you don't always have to buy the top-of-the-line model to get good quality. The lens is like the paintbrush with which you will create your masterpiece, and higher quality lenses will make a difference.

▣ Zoom Lens

A lens that allows you to shoot at a range of focal lengths. This means you can get wider views and tighter views of a subject without changing your camera position.

▣ Prime Lens

A lens that allows you to shoot at one focal length. To adjust your view of the subject, you have to change your camera position.

▣ Image Stabilization

The use of floating lens elements to compensate for camera movement and help attain a sharp image. This is a feature of some lenses.

▣ Lens Speed

The maximum (widest) aperture setting on a lens. The availability of very wide apertures makes it possible to use shorter shutter speeds to freeze action or when working in low light. Wide apertures also produce a very shallow depth of field, which is helpful for separating subjects from backgrounds.

▣ Bokeh

An aesthetically pleasing blur on out-of-focus areas, usually in the background of an image.

an 85mm. These are perfect portrait lenses that flatter people and react well in low-light situations. I would also have a good zoom lens in my bag for diversity's sake. A 70–200mm, 24–105mm, or 17–40mm lens will cover a good range of focal lengths and allow you to back away from your model.

Lens Hood

You'll also need a lens hood for those super sunny days. Lens hoods are inexpensive compared to the cost of a good lens, and they help protect your lens from unwanted bumps—something that is especially helpful in crowds. They also keep you from having to hold a scrim over your lens (or hold your hand up between your lens and the sun) to keep lens flare at bay. Lens hoods block direct light from entering the lens, light that can create flare and sun spots. Most lenses come with a lens hood, but if yours didn't, get one. And if your lens did come with one, make sure you use it.

Cleaning Kit

You'll need a basic cleaning kit to ensure that your camera and gear stay in the best condition possible. I frequently shoot on the beach and no matter how careful I think I am being, I always find grains of sand on my lens or near crucial camera buttons. Just give your gear a good cleaning before putting it away, and of course keep your lens free of fingerprints, dust, smudges, etc. Nothing ruins a perfect picture like a nice big speck of dust. Your camera's sensor will also need to be cleaned periodically, regardless of how careful you are when changing your lens. Use your lens caps and lens-mount covers judiciously to protect your investment.

1-3. A lens hood helps prevent image-degrading lens flare.

▦ **Sensor Cleaning**
Manually cleaning the glass filter covering the camera's image sensor to remove accumulated dust/dirt that produces image-degrading specks in your photographs. IMPORTANT: Consult the camera manufacturer's web site before attempting this operation.

QUICK TIP > A trick I was taught is to remove the lens with the camera body facing *down*, which should help prevent dust from settling into the body.

A Place to Meet Your Clients

If you don't have a studio or office where you can meet with clients to present their images and go over bookings and contracts, you will need a clean, comfortable location where you can meet for 30 minutes or longer. Coffeehouses, local restaurants, or even a safe park will work if that's all you have available. Even if the location isn't owned by you, in clients' minds it will represent you and your company, so choose wisely. Some photographers group together to share office space, others use a home office, and some swear by making house calls. Figure out what works best for you and your clients and go for it.

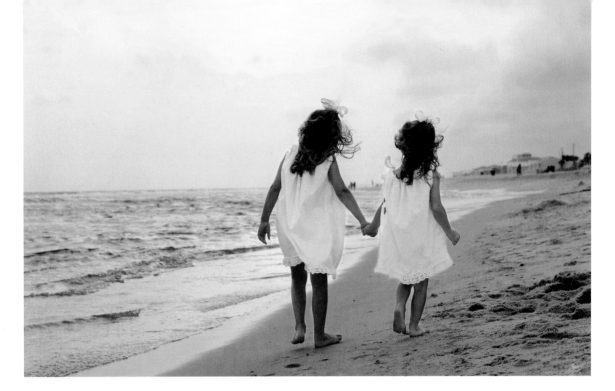

1-4. Two tiny sisters walked down the beach holding hands as the sun created amazing colors in the sky.

f/7.1, ¹/₂₅₀ second, ISO 200

QUICK TIP > When purchasing memory cards, choose a brand name that is known to be reliable. The peace of mind you will have from knowing your images are secure on this tiny piece of plastic is worth the increase in cost.

Tripod

A nice tripod is a good investment. You want something light-weight, since you will be carrying it most of the time—at least until you can afford assistants to lug your things! It also needs to be sturdy, and easy to fold/collapse when needed. Tripods are a must for time-lapse photography and when shooting at slow shutter speeds in lower light. Some photographers won't shoot even basic portraits without them.

Memory Cards

Don't go small with your memory cards. High-speed memory cards can boost your camera's performance, particularly when

1-5. High-capacity memory cards minimize interruptions during your shoot.

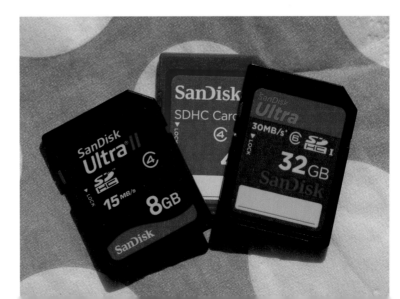

you are shooting images in quick succession. High-speed cards also have the upper hand when it comes to downloading or transferring your images from the card to your computer. The higher the capacity of your memory card, the less often you will have to change it—and nothing ruins the flow of a great shoot like having to take a memory card break.

Camera Bag

You will need a camera bag to haul all of your gear around. You can go sophisticated or utilitarian with just about every price point in between, but make sure it has enough room to carry your essentials—plus a little wiggle room for growing. Look for a model that is lightweight (camera gear is heavy enough on its own) and has enough cushion/padding to protect your investments from clinking together or getting damaged if you were to drop your bag, which happens to everyone at least once. It should also be comfortable to carry. This is entirely a personal thing; some photographers prefer the sleek good looks of a handbag-style bag, while others like to be able to sling their bag over one shoulder on mountain treks. Think about the environment you will be working in, your client base, and what style works best for you.

QUICK TIP > Invest in your camera bag. You don't want to put thousands of dollars worth of gear into the cheapest bag you can find, only to have a buckle break or a zipper pop and lose or damage your tools.

Lighting Gear

A Reflector. A reflector of some kind is a necessity, in my opinion. If you like, you can start

1-6. Active kids and families will keep you on the move during outdoor sessions, so a comfortable camera bag is a must.

f/2.8, $^1/_{320}$ second, ISO 500

off inexpensively with foam-core board. I know of at least one famous photographer who uses a good number of foam-core boards as scrims, backdrops, and reflective surfaces in her studio, and her work is amazing.

Foam-core boards are lightweight and inexpensive, plus they can be cut to fit your specific size needs. You can also use them as a fake wall or a bounce surface for flash. I've even turned them into a box for beautiful product photography! Foam-core board can be purchased at hobby and craft stores, art-supply stores, and office

supply stores. Wall-size sheets can be purchased at home-improvement stores. For location photography, the drawback of using foam core is that it doesn't travel well.

If you are shooting outdoors, the easiest solution is a collapsible reflector. These are lightweight, inexpensive, and durable. Most reflectors come in silver or gold, and 5-in-1 reflectors have a zip-off covering that includes a black side (to subtract light), a white side (to reflect available light without a color shift), a gold side (to reflect the available light and warm it up), and a silver side (for more intense fill light without a color shift). The inner core of the reflector is typically translucent and doesn't really reflect much light; instead, it works as a diffuser and softens the light passing through it to your model. Once you learn how to fold it up (I found this a bit tricky), the whole thing packs up neatly into a carrying pouch.

A Plain White Umbrella. I also have a couple plain white umbrellas in my supplies. A white umbrella is useful as a quick reflector, a small scrim from harsh sun, and a sweet prop. It's a necessity to continue shooting if a little

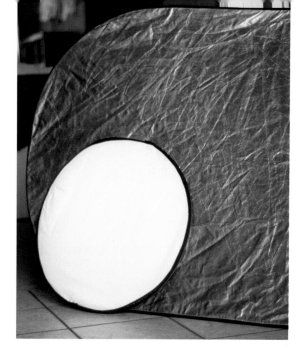

1-7. A reflector is a simple but invaluable tool for natural light photography.

Reflector Size

Don't choose the smallest reflector possible (it doesn't add much in the way of light and has even less function as a scrim), but don't go so large that you can't manage it yourself if necessary. I like my 40-inch round 5-in-1 reflectors because they are large but not excessive. With anything much larger than that on the beach, I might as well be wrestling a sail. Without a strong (and heavy!) assistant, the wind simply takes off with them. Indoors, I use a 36x48-inch reflector, along with large white foam-core boards that provide a softer quality of light than the reflectors.

Reflector

Any surface, existing in the scene or added by the photographer, that is used to redirect the light so that it falls on the desired area of the subject.

Scrim/Diffuser

A translucent panel used to scatter light rays as they pass through it. This transforms hard light into soft light.

Main Light

The primary (most intense) source of illumination on the portrait subject's face. This light creates the pattern of highlights and shadows that reveal contouring and give the photograph a three-dimensional feel. In natural light portraits, the main light is—either directly or indirectly (through clouds or a scrim, under shade, etc.)—the sun.

Fill Light

A secondary light source used to reduce the intensity (darkness) of the shadows created by the main light. In natural light portraits, fill is often added to a scene by adding a reflector by positioning the subject relative to some naturally reflective element of the scene (white sand, a reflective wall, etc.).

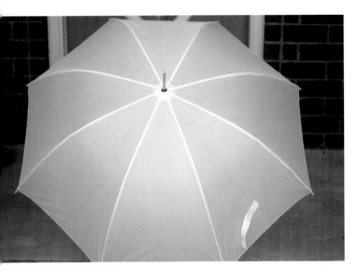

1-8. A white umbrella can function as a rain shield, reflector, scrim, or simple prop.

rain falls during your shoot. Of course, you'll need one for yourself and to protect your camera. Colored or patterned umbrellas will provide protection, but plain white ones will do the job without casting color shadows or affecting the white balance in your portraits.

Clamps. Heavyweight clamps from a local hardware store come in handy for holding up reflectors and backdrops. Adding a selection of these to your kit will be a good investment.

Licenses and Permits

Insurance. I personally feel that business insurance is crucial for anyone operating a legitimate photography business, even if you are set up as an LLC. Your state may even require that you have it in order to do business.

Equipment. Set up equipment insurance to cover all that fancy gear you have in case of theft, loss, or damage. You typically want to cover your camera body (or bodies), lenses, the computer you use for business, etc. Your insur-

ance agent will help you list each item and the value of each.

Liability. Liability insurance is a must whether you work in a studio or on location. While your client is with your business, you could technically be held liable for any injuries they sustain—no matter what the reason! You never expect any harm to come to anyone during a photo shoot, but even the smallest injury could turn into a liability nightmare if you aren't properly covered.

Disability. Disability insurance is critical if you depend on your income from photography. In the event that you become ill or hurt and can no longer work, disability insurance will kick in to help you cover the loss of income.

There are other coverages available to help protect you, your family, and your business but these three are on my list of the most crucial.

Business License and Sales Tax Certificate. In my area, in order to open a business bank account and be listed as a legitimate business, I had to file a DBA (or "doing business as") form, which lists the name of my business. In order to actually sell prints in the state of Florida, we also need a sales tax certificate from the Department of Revenue. Individual counties in my state decide whether or not we need an occupational license or a business license; some counties require both. You can Google "occupational licenses + your county/state" or "business licenses + your county/state" to get the contact information for your government offices. (Don't just take my advice; check with the appropriate government officials in your area to find out what is required and make sure you are covered!)

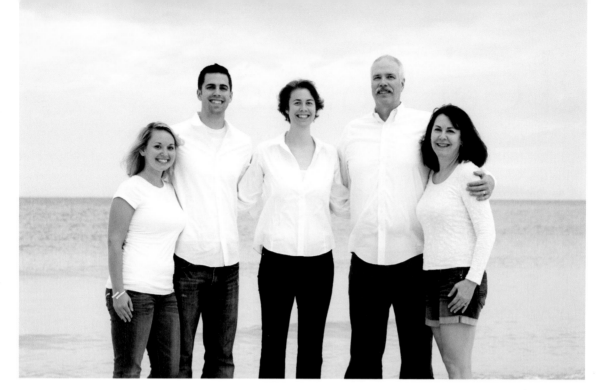

1-9 *(above),* **1-10** *(right).* Before heading out to a location, check to see if a permit is required to shoot there.

1-9: f/4.5, $^1\!/_{125}$ second, ISO 320
1-10: f/4.5, $^1\!/_{200}$ second, ISO 320

Shooting Permits. If you are shooting in an incorporated area of your county, typically, your county's permit rules apply. Unincorporated areas may not require a permit to shoot in—but, again, please check with your local government official to be sure. State parks typically allow photography for free (or with an entrance fee) without a permit. Private developments, gated communities, residences, or businesses may require a fee or permit—as well as proof of insurance—to use their property. Ignorance of the law does not excuse you from fines or penalties and may cause you to be ejected from the area! I can't imagine a less professional way to end a photo session with a client, so be sure you research *before* you plan your shoots.

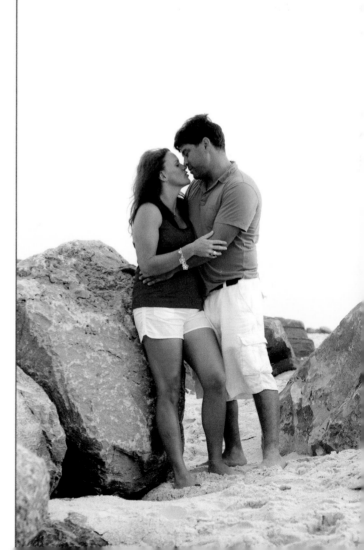

2. Get Started

LEARNING OBJECTIVES
- ❖ *Develop a cohesive style that inspires you*
- ❖ *Find models for available-lighting test sessions*
- ❖ *Establish basic color and exposure settings*

Know Your Gear

First things first: I strongly suggest that you know as much as possible about your camera and how to use it. There is nothing worse than having a fabulous model, location, and idea and not being able to bring it to life because you aren't comfortable with your camera. There are plenty of online tutorials to help you figure out all the bells and whistles for your specific camera model. Spend some time with these. Your camera can be your best friend if you treat it correctly, but it can be a fearsome foe when you don't know exactly what you are doing. You wouldn't try to drive a car without taking driver's education, right? Your camera can take you just as many places creatively as your car can take you physically. So know it, love it, and learn it.

Choose a Direction

Even if you are just starting out, you will want to take a minute to think about what direction you would like to head with your photography. Without direction, it's easy to wander aimlessly through the halls of professional photography as a newborn/child/family/boudoir/engagement/wedding/food/landscape photographer. While specializing in *everything* may sound impressive in the beginning, most professionals know that if you're specializing in everything, you can't take the time to master anything.

If you aren't immediately drawn to one specialty, try out a few different genres to see which you enjoy the most. You'll soon figure out if high-speed sports photography is for you or if sleeping newborns are more your speed. The idea is to pick a general subject area and learn as

2-1 *(facing page, top),* **2-2** *(facing page, bottom left),* **2-3** *(facing page, bottom right).* Children are my specialty because they are what I am most passionate about photographing. This leads quite naturally into family photography.

2-1: *f/5.6, $^1/_{250}$ second, ISO 200*
2-2: *f/1.8, $^1/_{1000}$ second, ISO 200*
2-3: *f/4, $^1/_{200}$ second, ISO 160*

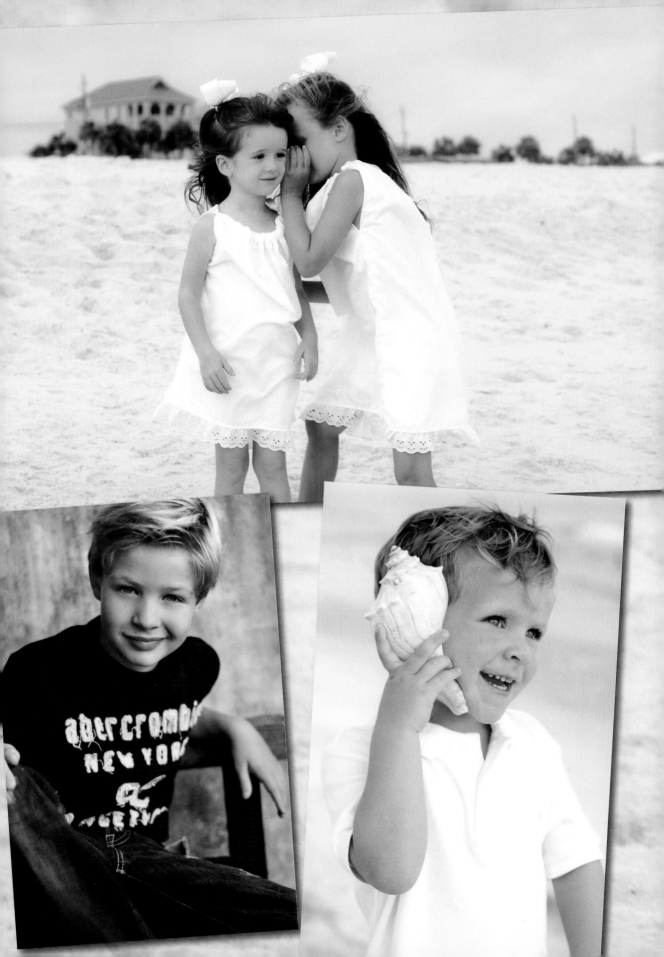

much as you can about photographing it beautifully. Then, when you're ready to tackle a new genre, you'll be well prepared to march confidently into new territories. It will not only give you the self-assurance you need to succeed, it will help your clients feel more confident about you and your business.

Find Your Style

Taking it a step further, beyond just the genre of photography you wish to work in, you must also find your style. Photography is a form of communication, and your style of photography is your voice. Your style comes from your choice of equipment, your work processes, your lighting and posing, and the environment in which you photograph.

My Style. For example, because I live near the beautiful, bright, sunny beaches of northwest Florida, I shoot a lot of light, colorful, happy images. That's exactly how the beach feels to me: light and happy with saturated colors and nice textures. However, I have found that even if the beach is not my backdrop, my images have that same naturally colorful feel.

Some of these components of my style are the result of technical choices. I like soft, natural light, wide-open apertures, and complementary background colors, so I choose to shoot with prime lenses (the 50mm f/1.4G and 85mm f/1.4G never leave my camera bag) and I post-process only to enhance the colors and brightness as needed.

You'll notice, though, that I also described my style as "happy"—and that's a quality that comes more from how I interact with my client than with anything I do using the camera. It is important to me that my clients have a good time during their

QUICK TIP > When considering your specialization, think about what appeals to you now—without your camera. If you could choose an office, would it be indoors, outdoors, or always changing? Would you rather spend time with kids or pets? Or maybe you're drawn to products like food or fashion? Let your personal interests point you in the right direction.

"I like soft, natural light, wide-open apertures, and complementary background colors . . ."

Complementary Colors

On the color wheel, complementary colors are located directly across from each other. For example, indigo is the complement of yellow, while red is the complement of green. Complementary colors create the maximum color contrast and create good visual interest, so this is helpful to know when making choices about backgrounds and clothing.

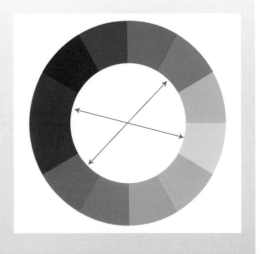

2-4. The color wheel, with arrows indicating pairs of complementary colors.

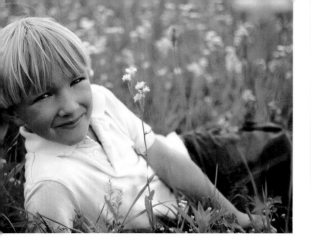

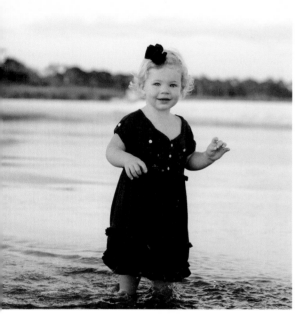

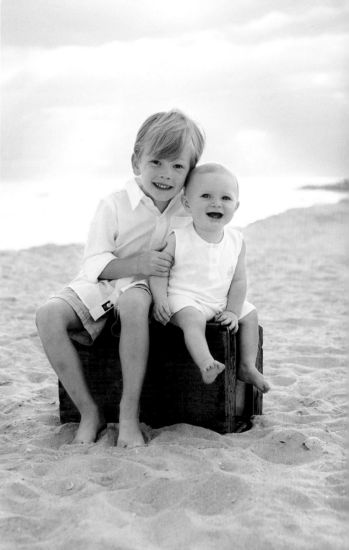

2-5 *(top left),* **2-6** *(top right),* **2-7** *(above),* **2-8** *(right).*
My style: lots of light, colorful, and fun.

2-5: f/2, ¹/₅₀₀₀ second, ISO 160
2-6: f/4, ¹/₅₀₀ second, ISO 160
2-7: f/3.2, ¹/₅₀₀ second, ISO 320
2-8: f/4, ¹/₁₂₅ second, ISO 400

photo session. Luckily, ensuring that they have fun leads right into being able to get relaxed, natural interactions between the family members. Not surprisingly, these images are my biggest sellers.

Emulate Others. It is never wise to simply copy someone else's style; however, I am of the

2-9 *(top left),* **2-10** *(right),* **2-11** *(bottom left).* Although it's my job to photograph such beauty, it never feels like a chore when I'm on location with my models. I want everyone to enjoy portrait sessions so much that they feel like they are just hanging out with a friend.

2-9: f/4.5, $^1\!/_{160}$ second, ISO 200
2-10: f/2.8, $^1\!/_{125}$ second, ISO 200
2-11: f/6.3, $^1\!/_{125}$ second, ISO 160

Tips for Finding *Your* Style

1. Think about what you want to say with your images. Do you want to find the beauty in everything or to illuminate the gritty cracks? Do you want to instill peace with your pictures or shock your viewers? Do you gravitate toward light and airy images or dramatic black & whites?
2. Think less about what you think others want and more about what speaks to you.
3. Look at visual mediums to borrow inspiration. You can find inspiration in books, literature, magazines, even album covers and music.
4. Whenever something moves you visually, jot it down or take a picture. Smartphones are so handy these days—and my notes apps are full of ideas I got at the supermarket or sitting on the beach.
5. Create a dream book filled with images, textures, colors, or even words that speak to you and can help shape your creative path—even for specific photo shoots.
6. Go on an inspiration hunt and take pictures of things that move you.
7. Look at décor and magazines you drool over and music videos you enjoy.

opinion that emulating your favorite photographers can help you learn how they crafted their images and help you arrive at your own style of imagery. When I started out, I was inspired by many amazing photographers. Anytime I was particularly drawn to an image, I would try to hash out its settings (what time of day it was, what lens was used, etc.) and then design my own image with similar lighting, settings, or poses—whatever it was that spoke to me about the inspiration image. Fairly quickly, I took it up a notch; I was still re-creating, but with some element that was completely different to see how unique I could make my image look. Soon, I had a style that I was comfortable touting as my own. When I was confident I could reproduce that style in almost any situation—voilà!—my brand was born.

If you are artistically moved by the work you are striving to create, it will not only feel less like a chore to go to work every day, it will inevitably shine through in the quality and intensity of your work.

Build Your Portfolio

Once your style begins to take form, your portfolio should reflect this so that your future clients will know what to expect from you. Create your portfolio with your desired clients in mind, because you will attract what you show.

2-12 *(top),* **2-13** *(bottom).* A photogenic woman who enjoys the camera makes an easy subject as you practice your lighting skills and posing.

2-12: *f/4,* $^1/_{160}$ *second, ISO 250*
2-13: *f/2.8,* $^1/_{400}$ *second, ISO 320*

2-14 *(left)*, **2-15** *(right)*. Look for a subject who has either worked professionally as a model or is an aspiring model—then experiment with some fun ideas.

2-14: f/2.8, ¹/₁₂₅ second, ISO 800
2-15: f/2.8, ¹/₁₆₀ second, ISO 640

It's fairly easy to find models who are willing to pose for you while you are building your portfolio, as most people love having great images of themselves and their family members.

"You want models who are patient, open-minded, and easy to work with as you perfect your shooting style."

You can ask friends and family, advertise online in forums, and post a call for volunteers on social media sites like Facebook. You can even contact a local modeling agency and see if any models there would be willing to trade their time for your images of them (usually on CD or digital download). There are models of all shapes, sizes, and ages at most agencies, and it's a good opportunity to meet new people, as well. Many newer models are trying to build their own portfolios and skills, but they typically have a bit of experience and are more comfortable in front of a camera than your average friend, which may be helpful as you try new things. You want models who are patient, open-minded, and easy to work with as you perfect your shooting style.

There are many children who love to pose, too, and can help you develop your style and

rapport if you aren't already comfortable with kids. Most big cities have at least one modeling agency that represents children, and many will happily put out a casting call for you so that you can practice with willing participants.

Time-for-photos (TFP) arrangements have become so common that almost everyone is familiar with sitting for a photographer in exchange for digital images or prints. It's the perfect way to explore your shooting style and learn how to handle clients you aren't related to before you actually start charging. Remember, once you start charging clients, you are liable for their happiness with your services as well as their safety while they are with you, so you want to be as prepared as possible before you break out the cash register. When photographing anyone you don't know, be sure to meet in a safe location, spell out your terms clearly, and have them sign your model release.

Exposure Modes

Skip the Automatic Mode. Cameras today are miraculous. They are packed full of pixel potential, have facial recognition,

2-16. I'm lucky to have my own little ham living under my roof. Carson has been comfortable with the camera since he was a toddler and sits patiently while I try out new lighting or posing. I pay him in Hershey's bars.

f/5, $^1/_{100}$ second, ISO 400

2-17. This little beauty got her start practicing her modeling skills with me and went on to book commercials and other work.

f/1.8, $^1/_{400}$ second, ISO 200

2-18. I think this handsome boy got his posing skills from his mama, who was a model and state pageant winner. This made photographing his sweet face a breeze.

f/4.5, $^1/_{125}$ second, ISO 320

autofocus, automatic light metering, in-camera editing capabilities—you name it. Unfortunately, when you set your camera to the automatic mode and let it use all of these complex features and equations to capture images, you're letting it make all the decisions for you. In fact, all *you* are actually doing is framing the shot. Running your camera on automatic is like buying a Ferrari and having an automatic transmission put in! Sure, it will still run well and it will probably go fast, but you won't get the same performance as a driver who knows the precise moment to shift gears and can adjust on the fly for the curves in the road.

> "When you set your camera to the automatic mode, you're letting it make all the decisions for you . . ."

Shoot in Manual Mode. As a professional photographer, you want your images to look professional. Aside from composition rules, knowing how to run your camera on *full manual* truly marks the difference between a "pretty good amateur" who just loves to shoot and a professional portrait artist. So get comfortable with manual shooting first. Then (and only then) can you make the decision to come out of the manual mode in certain circumstances where some auto-piloting is helpful. See the box to the left: "Semi-Automatic Modes (Sometimes)."

For the purposes of portrait photography, we're sticking with manual; it's the mode I shoot in 99 percent of the time. I know I'm lecturing, but it's because I care. I see too many people with great creative eyes get a wee bit lazy; they stick their camera on automatic or aperture priority and make some nice shots but then wonder why they don't seem to progress or produce consistently amazing images. Once you take back the wheel—or is it the stick shift? I'm terrible at metaphors!—you truly can drive your photography career anywhere you want to go. (See what I did with that? I promise, that's the last of the cheesy car references.)

Google "how to shoot in manual mode" and you'll find approximately 13,479 awesome

Semi-Automatic Modes (Sometimes)

I sometimes switch over to semi-automatic modes like aperture priority or shutter priority when I am casually photographing kids at sporting events while I watch the game and chat with friends. The aperture priority mode is useful for portraits where you want to control the depth of field around your subject—especially if you are in a location where the light is changing rapidly. The shutter priority mode is useful for moving subjects, letting you consistently freeze the action with a high shutter speed or capture some motion blur with a slow shutter speed.

▦ **Automatic Exposure Mode**
The camera sets the ISO, aperture, and shutter speed.

▦ **Manual Exposure Mode**
The photographer sets the ISO, aperture, and shutter speed.

▦ **Aperture Priority Exposure Mode**
The photographer sets the aperture for the desired depth of field; the camera sets the ISO and shutter speed.

▦ **Shutter Priority Exposure Mode**
The photographer sets the shutter speed for the desired motion-stopping or motion-blurring effect; the camera sets the ISO and aperture.

Basic Exposure Settings

Exposure is, in its most basic terms, the amount of light that hits the sensor. This is determined by your camera's shutter speed, aperture, and ISO settings.

Shutter Speed

The shutter speed is the length of time the camera's shutter is open. This is mostly shown in fractions of a second ($1/125$ second, for example)—except for speeds longer than 1 second, which are shown as whole numbers. The faster the shutter speed, the shorter the time the shutter is open (less light is allowed to hit the image sensor and the image is darker). Faster shutter speeds can also help to freeze moving subjects. The slower the shutter speed, the longer the shutter is open (more light hits the image sensor and the image is brighter). Slower shutter speeds can also help to blur moving subjects.

Aperture

The aperture setting controls the size of the lens opening through which light enters the camera and, therefore, the amount of light that hits the image sensor. Aperture settings are expressed as f-numbers. Lower f-numbers (such as f/1.4) correspond to larger lens openings, allowing in more light and making the image brighter. Higher f-numbers (such as f/22) correspond to smaller lens openings, allowing less light to enter and making the image darker. The aperture also controls the depth of field. The higher the f-number, the greater the area of focus. The lower the f-number, the smaller the area of focus.

ISO

The ISO setting determines the sensitivity of the camera's sensor to light. The higher the ISO number, the more sensitive to light the sensor is. As a rule of thumb, use the lowest ISO setting possible for the light you have available to decrease the amount of grain in your image. ISO 100 is for very sunny days, ISO 200 to 400 will work for morning and afternoon light and cloudy days, and ISO settings above 600 will be needed for dim light, indoor shoots, and nighttime photography.

The best way I have come across for explaining the relationship between these three controls is the "water bucket" analogy. If the goal is a full bucket of water (a proper exposure), the ISO is the size of your water bucket, the diameter of the garden hose is your aperture, and the amount of time the water flows is the shutter speed. With a larger hose (wide aperture), it will take less time (shorter shutter speed) to fill the bucket. If you want to adjust the fill time, the size of the bucket, or the size of the garden hose, you have make reciprocal adjustments to at least one of the other factors.

pages with step-by-step instructions, books from amazing photographers who will walk you through it, and YouTube videos from every corner of the world. Pinterest has oodles of pins featuring helpful hints for those of you who like their lessons compact and easily digested. If you are more of a hands-on kind of learner, there are photographers in almost every city, as well as colleges, who host classes for beginners. In the meantime, see the box above ("Basic Exposure Settings") for some terms you should know as we move forward.

Exposure Metering

How do you know what settings to use to create a proper exposure in any given situation? You can use a handheld light meter to give you a reading, or you can rely on the meter right inside your camera to measure the light and point you toward the appropriate settings. There are a few different metering modes on DSLR cameras (the names of the modes vary slightly between camera brands, but the basic features are very similar).

Center-Weighted Metering. As the name implies, center-weighted metering tells your camera to take its reading from the center of your image. This is the most commonly used mode for standard portraits. It assumes that your model will be close to the center of the frame and that you will want that area to be properly exposed. The data used to calculate the exposure then feathers out to the sides, giving those areas less consideration. If your subject is *not* centered, or if your background has a lot of contrast, this is probably not the best metering mode to use.

Partial Metering. Partial metering is a bit more specific; it only uses 10–15 percent of the center of the frame to meter. This works well in situations where your model is surrounded by bright light (backlit) to ensure your model is properly exposed—or if your model is in front of a very dark background.

Spot Metering. Spot metering is extremely precise and reads the light from only 1–5 percent of your frame. If you have a high-contrast situation or your model is surrounded by a considerable amount of bright surfaces (like snow), spot metering can help you pinpoint the right settings. This mode is a bit tricky, though, so practice is required.

> "This works well in situations where your model is surrounded by bright light . . ."

QUICK TIP > Check your camera's manual to see if the spot metering point is fixed in the center of the frame or if you can change the location of the metered area, placing it over an off-center focal point.

2-19. Icons for the common camera metering modes.

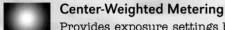

Center-Weighted Metering

Provides exposure settings based primarily on what's at the center of the frame, then feathering outward. This assumes that the most valuable information about the lighting is found near the center of the frame.

Partial Metering

Provides exposure settings based on 10–15 percent of the center of the frame. This makes it perfect for backlit portraits.

Spot Metering

Provides exposure settings based on 1–5 percent of the center of the frame. This is useful for high-contrast scenes or when you want to ensure a specific area is perfectly exposed.

Evaluative (Matrix) Metering

Provides exposure settings based on a zone-by-zone comparison of the frame to a stored database of images.

Evaluative (Matrix) Metering. Evaluative or matrix metering is the top of the line, as far as metering modes go. It grids off your image into little zones and takes a reading from each zone, then compares those readings to a database of stored images to give you the best estimate on proper exposure. This is an easy default mode and probably what your camera uses when you set it to automatic.

White Balance

Have you ever taken a photo, only to find that the whites are more like blues? Or that everything seems to be orangey-gold? The color of the light surrounding your model definitely affects how your image will be captured. We won't get too technical, but you do need to know a little bit about the color(s) of the light source(s) you are using in order to get true colors in your images. Here's a quick rundown of the types of colors in light you are likely to run into and how to work with them right in your camera by adjusting your white balance.

Automatic White Balance. The default for most cameras is the automatic white balance setting, which basically picks the brightest part of your image and assumes it is white. All other color calculations are then based on that. This works pretty well,

> "Have you ever taken a photo, only to find that the whites are more like blues?"

◫ White Balance

A system of software adjustments made by the camera to compensate for different colors of lighting. For example, incandescent lighting tends to be yellowish, so the camera adds a bluish filtration to compensate and render the recorded colors in a more neutral way.

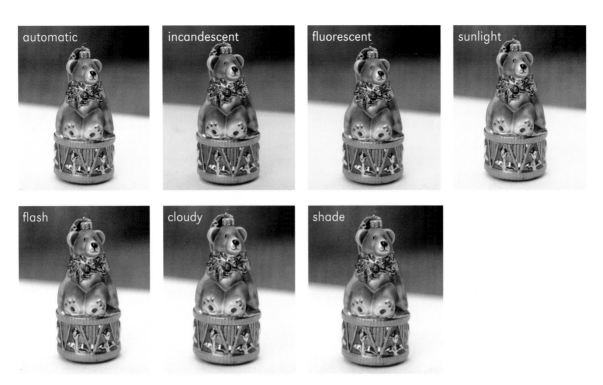

2-20, 2-21, 2-22, 2-23, 2-24, 2-25, 2-26. These images of my son's favorite Christmas ornament were all taken in the same lighting and with the same exposure. The only thing I changed was the camera's white balance setting to illustrate the way each mode slightly tints your image to combat tricky lighting situations. I included a white table as well as a darker background and chose an item that was small but had multiple colors so that the color effect of each setting can be clearly observed.

but it is letting your camera make decisions that can sometimes negatively impact your image.

Outdoor Presets. The light from the sun can change dramatically depending on the weather conditions and the time of day. We've all seen images of sunrises and sunsets and marveled at the amazing range of colors in the images, right? Those colors are not only reflected in the sky and scenery; they affect the colors of your subject as well.

When the sun is high and in a mostly cloud-free sky, you should try the daylight or sunny white balance setting. This sets your white point with a slightly warm tint to counteract the harsh blue of the midday sky, making your image appear more natural. To me, portraits shot this way still seem a bit cold, but I like my images fairly warm.

If there are clouds in the sky, the sky seems a bit gray, the day is overcast, or you just want a warmer image, try using the cloudy white balance setting. This adds a slightly yellow/orange tint to counteract the bluish lighting.

Shooting in full shade can be a bit tricky because the light tends to be fairly blue (not a great look for portraits). You can warm up those skin tones and bring things back to a more natural color balance by using the shade white balance setting, which is a bit warmer than the cloudy white balance setting.

AWB	**Automatic**	*Camera balances lightest part of frame to white.*
	Sunlight	*Camera adds subtle warm tones.*
	Cloudy	*Camera adds moderate warm tones.*
	Shade	*Camera adds stronger warm tones.*
	Tungsten	*Camera adds blue tones.*
	Fluorescent	*Camera adds orange tones.*
	Custom	*Camera balances photographer-selected area to white.*

2-27. White balance settings and effects. Different cameras may use slightly different icons to represent these settings, so check you camera's manual if you are unsure.

Indoor Presets. Indoor lighting varies greatly depending on what type of bulbs you have in your light fixtures, as well as the color of the wall paint—or even the color of the dominant furniture inside. Indoor light can be reddish, bluish, yellowish, or greenish, and of course paint comes in a full rainbow of hues. The fluorescent and incandescent white balance settings are the ones you will most commonly use to eliminate the tints caused by their corresponding bulbs. If you aren't sure what kind of bulb is used in an area's light fixtures, or if there is a mix of bulbs/light sources in the room

where you are shooting, look for the predominant color. Warmer orange light can be counteracted by the incandescent white balance setting; greenish-gray light can be counteracted by the fluorescent white balance setting.

Custom (Manual) White Balance. You can also use a custom white balance setting, sometimes called manual white balance, to more precisely define how you would like your image captured. Different camera models handle this differently, but the basic procedure involves taking a full-frame picture of something pure white or neutral gray under your current lighting conditions. The camera then calculates the color settings required to capture the known tone accurately and applies the same settings to your successive shots. Gray cards are pretty inexpensive, and it only takes one shoot with horribly botched skin tones to make most photographers run to their nearest camera supply store to purchase one. It is far better to capture everything right, in the camera, than to rely on post-processing for color correction. Save that time for artistic additions to your work—or, better yet, a nap!

Now that you know what all the buttons on your camera are for, we're ready to tackle the fun stuff.

White Balance for Creative Effect

Traditionally, the camera's white balance settings are used to adjust the capture so that the whites in your image are as truly white as the whites in your scene—and all other colors represented are rendered in correlation to that white point. There's no reason you have to use the white balance settings only that way, though. You can also use the white balance settings to tint your image for artistic interest. To add an overall blue tone outdoors, you could shoot with the tungsten white balance setting, for example.

3. Outdoor Locations

LEARNING OBJECTIVES
◆ *Identify potential portrait locations*
◆ *Evaluate the look and lighting at potential locations*
◆ *Make the right choice for the shoot requirements*

*Y*our bag is packed with your essential camera gear and you have a great model who is willing to sit for you. Now all you need is a location. Let's look at some factors to consider—and some ways to make the most of what your environment presents.

The Shoot Requirements

When choosing a location, look for a place that fits the idea of your shoot. You want a pleasing background without a lot of distracting elements, such as power lines, trash cans, or a ton of people. (Unless, of course, it's a gritty urban portrait with power lines framing your beautiful

"Keep in mind how much room you will need if working with multiple models or family members."

model juxtaposed against trash cans and people walking by.) Also, keep in mind how much room you'll need if working with multiple models. You also want nice light to work with—but we'll consider that specifically in chapter 4.

Location Scouting

Ever notice how when you are on vacation in a different city you see perfect portrait spots everywhere? Everything seems picturesque and sweet, and you easily pick out a dozen spots that would photograph beautifully. These same spots exist in your hometown, no matter where that is. You are just so accustomed to seeing these sights that you hardly notice them anymore.

When you are driving around, consciously keep an eye out for interesting textures and shapes. Slow down and consider locations from a new perspective. Try to view your regular commute through creative eyes, or take a new way home so that you can check out streets you would otherwise overlook. You can save gas by perusing sites such as Flickr's geotagged maps,

3-1 *(left)*, **3-2** *(right)*. Natural elements, such as trees, give a comfortable, homey feel to images where formal posing rules need not apply. Trevor's red shirt made him stand out from the yellow leaves. Images like these show the child's personality and are a good reminder of what he was like at the time.

3-1: f/4.5, $^1/_{400}$ second, ISO 250
3-2: f/4, $^1/_{500}$ second, ISO 250

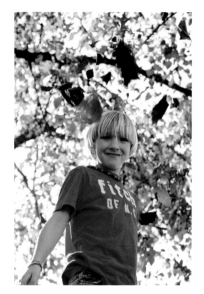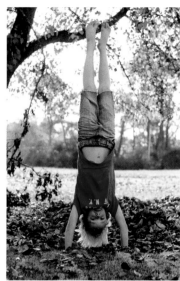

where generous members have posted their own beautiful images and then tagged their location for you. And don't neglect what's right under your nose; you may have some great portrait backgrounds right in your own backyard.

I use my cell phone to snap photos of backgrounds I think could be interesting, then add a note about the location. Not only can I flip through these shots to get ideas, I can show them to clients to get their opinions. I also make notes about possible vehicular or foot traffic in the area and make sure to call ahead to find out what permissions we may need to shoot there.

Locations can look different depending on the time of day. I love the brick walkway in the heart of Rosemary Beach, Florida, but it's often crowded. One evening, while doing a portrait session on the green space nearby, I was excited to see it mostly empty, so we hurried over to capture some images of these sweet girls (**image 3-3**). Perfectly framed by the trees behind them, they stopped to give each other a kiss and I got a shot that's one of my favorites.

3-3. Most of the day, this walkway is crowded with foot traffic.

f/3.2, $^1/_{160}$ second, ISO 250

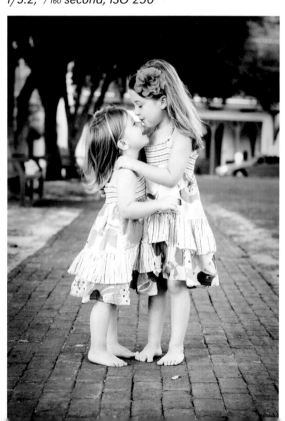

QUICK TIP > To explore locations by viewing geotagged images on Flickr, go to www.flickr.com/map, browse to the location you want to explore, and click "search this map."

Look Beyond the Obvious

Scrolling through portrait photographers' blogs and Facebook pages, it's easy to think that you need a sweeping vista with brilliant purple flowers, a stunning antebellum mansion, or some amazing abandoned warehouse with just the right amount of edgy grunge.

If you have such places within your reach, use them—but know that fantastic photo backgrounds often look far less fantastic in real life. What appears to be an endless field of wildflowers may have been a small patch of color within a grubby field in the middle of a neighborhood. Urban shoots are often tightly composed to ex-

clude less-than-desirable elements. Colors are enhanced, telephone poles are removed, and seaweed is cleaned off the beach (I know this one from experience!). You aren't always going to be able to find a ready-made set just waiting for you. You need to develop an eye for locations and know how to selectively include or exclude certain aspects from your location using camera angle, focal length, and aperture.

At the Beach. Images 3-4 and **3-5** are from an evening portrait session on the beach. Of course, we didn't realize until we arrived that it would be one of the busiest days in park history. By then, it was too late to find another location or reschedule, so we found niches around the area that were less crowded for the majority of our images. The family really wanted to try to capture one last portrait with the dunes in the background and even though the light was quickly waning and the crowds were ridiculous, I agreed to give it a shot. While I wouldn't

3-4, 3-5. The location is what you make of it.

f/4, ¹/₁₆₀ second, ISO 640 for both

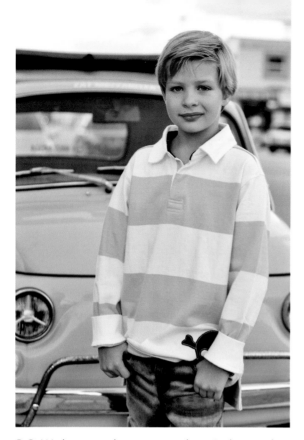

3-6. We happened upon a car that nicely complemented Carson's shirt.

f/3.5, ¹/₂₀₀ second, ISO 200

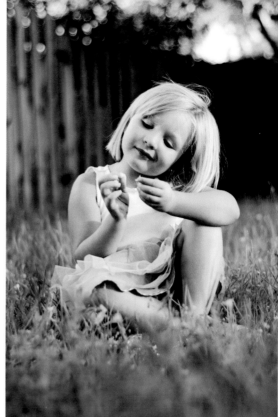

3-7. Shooting wide open softened the fence and dappled light, turning the corner of our yard into a nice background.

f/2.8, ¹/₁₀₀₀ second, ISO 320

normally spend this much time in Photoshop removing elements from an image, I felt like challenging myself to see how well I could clean up the background. It serves as a dramatic reminder that those "perfect" images you see may not always be so perfect in real life. It's best to shoot as close as possible to the way you want your final product to look, but it's nice to have the option of Photoshop for times like this.

On the Street. My son Carson has worked as a child model for a few years. On one occasion we were in Miami, scouting locations for headshots (**image 3-6**). A pizza delivery car parked on the street complemented the shirt he was wearing, so we grabbed a few images in front of it to make an interesting three-quarter length shot for his portfolio. A wide-open aperture helped blur out the businesses on the street behind him and simplified the shot. Be on the lookout for unusual things in your environment that complement or enhance your image for interesting portraits.

In the Backyard. No fancy location was necessary for **image 3-7**; the corner of our own backyard made a perfect backdrop for my daughter while she played with flowers. The dappled light in the tree branches turned into a soft, round bokeh with the use of a wide-open aperture. This also softened the harsh lines of the fence, leaving the emphasis clearly on her.

Versatility Is Key

Even the best spot has limited potential if it is only usable in one way. You want to be able to move around to different angles and capture unique images on each visit. Often, you can use one location for a variety of looks within one session. Don't be afraid to get low on the ground to check out the view, or cross the street to see how a building looks from farther out.

I don't want to waste time dragging a client to multiple locations, so I look for places that have some variety relatively close by. For example, a street that has multiple building textures along it to add interest can be shot long to include multiple buildings or tightly to change the look (see **images 3-11** through **3-16**). A few different doorways or entryways change the look again, and an alley can provide multiple angles to shoot from, including a staircase and some industrial grating.

Simple Backgrounds

I love fully stylized photo shoots with tons of details, but my favorite photo locations are often plain but versatile. The doorway in **image 3-8** is

QUICK TIP > When choosing a location, try to see how many ways you can use it to make the most of your time—especially when you are in a race against the setting sun.

Posing Aids Increase Variety

When working with the general public, people who may be a little uncertain in front of the camera, you'll get better, more natural posing variations when you give them something to interact with. Doorways, fences, railings, chairs, and stools all naturally suggest a few familiar positions to most people.

interesting in the simplicity of the shape and its symmetry, and provided a perfect backdrop for this family portrait in Rosemary Beach, Florida. I was looking for areas that would frame the family and complement their bright clothing without taking the emphasis off of them. Fun shapes, clean lines, and neutral color palettes make amazingly diverse backdrops.

In **image 3-9**, two little boys sit in front of the same doorway I used in the previous shot. I liked how large the doors were compared to

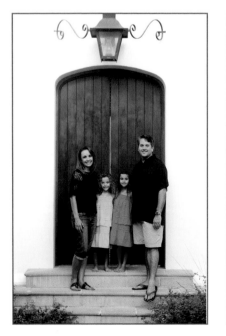
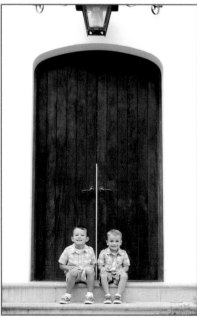

3-8 *(left).* Simple backgrounds are often my favorites.

f/4.5, ¹/₁₂₅ second, ISO 250

3-9 *(right).* The simple doorway established a contrast between the small boys and the big world.

f/2.8, ¹/₁₂₅ second, ISO 400

3-10. I had this trio walk along the brick pavers to capture some natural poses as I walked backwards. The scenic street was not busy at this time of day, and the speed limit is extremely low, so we were able to move as necessary. Still, I would only attempt this shot in an almost-deserted area where foot traffic is expected, and with older models who are able to follow safety directions.

f/4.5, 1/320 second, ISO 400

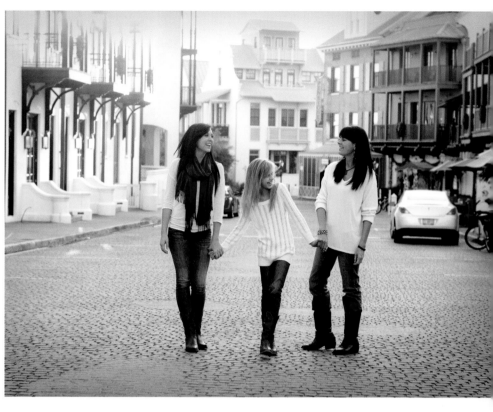

the boys and purposely asked them to sit down rather than stand, because I wanted to emphasize the idea of how small they were and how big the world is. Look for ways to photography creatively rather than repeating stale ideas to keep your work fresh and inventive. Not all of your ideas will work, but pushing yourself to be creative helps you grow as a photographer.

Safety First

A final note about scouting for locations: Safety is your number one priority. You must never put your clients or yourself in a dangerous situation. Dilapidated and abandoned houses may look interesting as a backdrop, but if you are not certain that the house is stable and safe, it should not even be considered. It may seem like a significant allusion to the turning point in their lives to photograph seniors in the middle of a street, but consider the safety of the location carefully before you have anyone lie down on the double yellow lines. Railroad tracks are not only overdone and dangerous as a photography background, it is also illegal to trespass on them. Every year, there are a few reports of photo subjects dying at locations such as railroad tracks or waterfalls, and it is heartbreaking because it is completely preventable.

What to Look For in a Location

1. Safety for you and your client.
2. Fulfillment of shoot requirements.
3. Sufficient space for the number of models.
4. Appealing shapes, textures, and colors.
5. Issues you might need to address in postproduction (phone poles, seaweed on the beach, etc.).
6. Versatility (multiple options in one area).
7. Availability of posing aids.
8. Lighting at different times of day.
9. Amount of foot traffic.

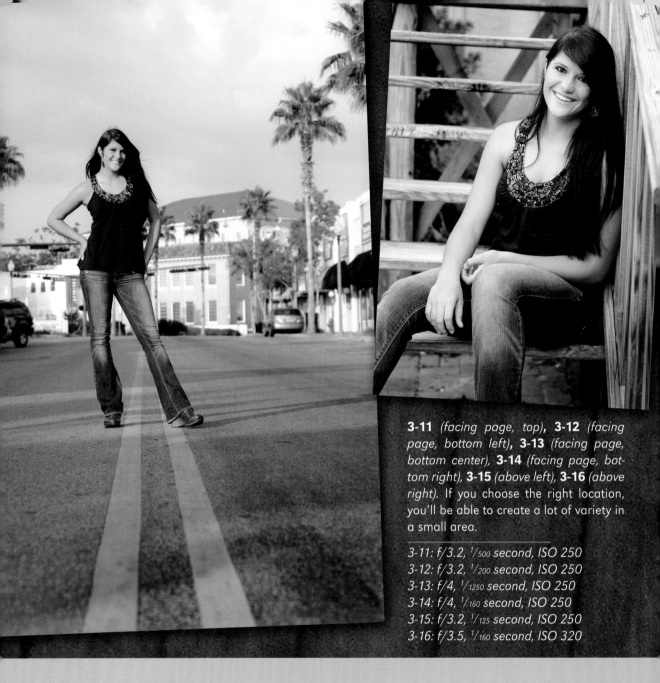

3-11 *(facing page, top)*, **3-12** *(facing page, bottom left)*, **3-13** *(facing page, bottom center)*, **3-14** *(facing page, bottom right)*, **3-15** *(above left)*, **3-16** *(above right)*. If you choose the right location, you'll be able to create a lot of variety in a small area.

3-11: f/3.2, $^1/_{500}$ second, ISO 250
3-12: f/3.2, $^1/_{200}$ second, ISO 250
3-13: f/4, $^1/_{1250}$ second, ISO 250
3-14: f/4, $^1/_{160}$ second, ISO 250
3-15: f/3.2, $^1/_{125}$ second, ISO 250
3-16: f/3.5, $^1/_{160}$ second, ISO 320

Six Looks on One City Block

Images 3-11 to **3-16** were shot on one city block. This allowed the model plenty of time to pose in multiple ways without rushing to change locations, and it saved us from a lot of walking. This senior wanted some urban style for her portrait session, so we headed to the downtown area on a Sunday evening when we knew it would be quiet to shoot. All of these images were taken literally within a few feet of each other, simply by changing the angle I shot from or by turning my model around to face a different direction. As we crossed the street from the brick wall, we captured the mostly empty street and then used the grassy area on the other side. The metal gate and staircase were tucked into an alleyway at the end of the block.

4. Outdoor Lighting

LEARNING OBJECTIVES
- ◈ *Evaluate and adjust the quality of the available light*
- ◈ *Position your subject relative to the light*
- ◈ *Work in open shade, dappled light, and under cloudy skies*

After safety, the most important consideration when deciding how and where to create your portraits is the natural light. Since you aren't going to be setting up any extra lighting equipment, you need to carefully evaluate the existing light in the scene. The time of day and the weather will affect your

lighting situation, so try to check out your desired location at various times and get a feel for how the sun plays in that area. We'll specifically consider the effect of shooting at different times of day in chapter 5.

For the moment, though, take a look at the little girl in the middle of **image 4-1**. She was photographed with the women in her family early in the evening, when a few clouds over the sun provided nice, even lighting on everyone. In **image 4-2**, the same girl was lit up with a golden glow as she sweetly hugged her dad just a few minutes later, when the sun had lowered and come out from behind the clouds. The two images have a different feel because the light changed so much in a short time. These are the kinds of opportunities we have to be aware of when working with natural light on location.

> "Check out your desired location at various times and get a feel for how the sun plays in that area."

The Amount of Light

On the most basic level, you want your chosen location to have enough access to the sun or reflected light to be able to

4-1 *(above)*, **4-2** *(right)*. These two images have a different feel simply because the light changed.

4-1: f/5, ¹/₁₂₅ second, ISO 200
4-2: f/3.5, ¹/₂₀₀ second, ISO 200

capture nice details. You also want to be able to use a low enough ISO that you can comfortably shoot with your preferred aperture and shutter speed settings.

The Quality of Light

The hardness or softness of the light that is available contributes strongly to the overall look and feel of your image.

Hard Lighting. Hard lighting is created by a small, direct light source, such as the sun when it is not softened by clouds or reflected by surfaces around your model. Portraits created under hard lighting have a sharp falloff from

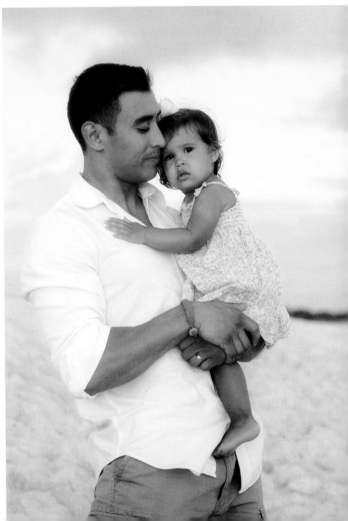

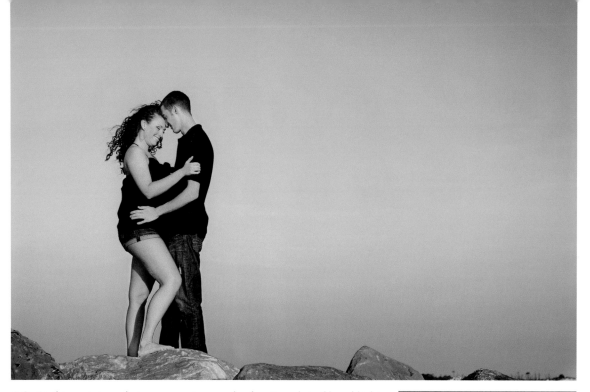

4-3. At this point, early in our session, we had quite a lot of hard light with no clouds to diffuse it. The sky was brilliantly blue, but my models were squinting quite a bit. I asked them to climb up on the rocks and simply pose close together with their eyes closed. This allowed me to capture a beautiful image of the two of them against a perfect blue backdrop, highlighting their sweet relationship.

f/5, ¹/₁₆₀ second, ISO 100

the highlights of the image to the darkest shadows with little transition area in between. This type of lighting clearly defines a model's features (the nose, cheekbones, and jawline) and not always in a complimentary way. It is often interpreted as a bit more edgy, moody, or artistic in portraiture—but as **images 4-3** and **4-4** show, hard light also has a crisp look that is sometimes perfect.

4-4. Bright sunlight on a clear evening illuminated everything and made the images crisp and colorful, perfect for these playful sisters.

f/5, ¹/₁₂₅ second, ISO 250

> ▦ **Hard Light**
> Light from a small direct source that creates a narrow highlight-to-shadow transition.
>
> ▦ **Soft Light**
> Light from a large, indirect source that creates a broad highlight-to-shadow transition.

Soft Lighting. Soft lighting is created by a large, indirect light source, such as the sun when it is softened by clouds or reflected by surfaces around your model. Portraits created under soft lighting have a gradual falloff from the highlights of the image to the darkest shadows with a broad, gentle transition area in between. This type of lighting is highly desirable in portraiture because it is flattering to everyone, young and old. The soft shadows enhance and sculpt the features of your model while the light gently evens out slight imperfections and highlights key features. **Images 4-5**, **4-6**, and **4-7** show how appealing this look can be.

4-5 *(bottom left).* Soft, evening light made these images feel quiet and gentle, which was perfect for this little family.

f/4, ¹/₂₅₀ second, ISO 160

4-6 *(top right).* After the sun set on a wild and crazy session with these two boys, the dimmer light provided the opportunity to capture a few sweeter moments between them.

f/3.5, ¹/₂₀₀ second, ISO 800

4-7 *(bottom right).* Soft light clearly showed off the little boy's adorable features in a simple portrait.

f/3.5, ¹/₁₆₀ second, ISO 400

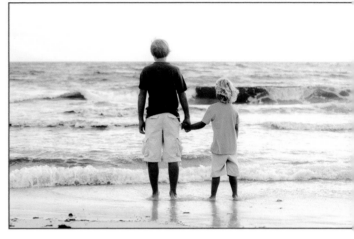

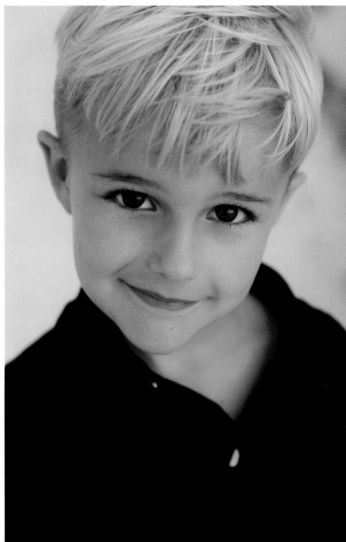

Light Quality Sets the Mood. Hard lighting definitely lends a different mood to your images than soft lighting. **Image 4-8** features a beautiful girl with exquisite blue eyes that seemed to be full of wisdom and humor—even though she was just five at the time. I posed her next to a large dining room window on her right and let the shadows on her left remain dark (without using a reflector to even them out). The result is a more dramatic, striking image than if I had turned her to face the window or lit her evenly. Notice how much sharper the shadow lines are in this image than in **image 4-9**.

For **image 4-9**, light from the evening sun was diffused by pine trees around us, which produced soft, pretty lighting on this adorable face. While the shadows still sculpted her cheeks and forehead, they were much softer and made for a sweetly innocent portrait. Notice that the transition between the brightest areas and the darkest shadows is much smoother and less pronounced than in **image 4-8**.

The Direction of the Light

In the studio, we can change the direction of the lighting by changing the position of the light source. Unfortunately, you can't change the direction of the sun, but you *can* adjust your subject's position and your own position relative to the sun. This effectively changes the direction at which the light falls on the subject, allowing you to use the same light to produce a variety of looks, even when the images are taken only seconds apart. Even in one location, you can completely change the feel of your images simply by moving around and exploring the light.

4-8. Notice how much sharper the shadow lines are in this shot than in image 4-9.

f/3.2, ¹/₁₂₅ second, ISO 200

4-9. Softer lighting gave this portrait a more innocent look than image 4-8.

f/4, ¹/₁₂₅ second, ISO 500

Add a Diffuser

Hard, direct sunlight can be transformed into soft lighting with the proper placement of a diffuser panel between your model and the sun. These translucent panels are used to scatter the direct beam into a more manageable and flattering glow of light. To change the amount of light diffused, experiment with your diffuser's angle and distance to the subject. I carry along a variety of strong clamps and bungee balls that I use to attach my diffuser to things such as tree branches, door frames, and blinds if I am shooting by myself. Available at most home-improvement stores, these are inexpensive and extremely versatile.

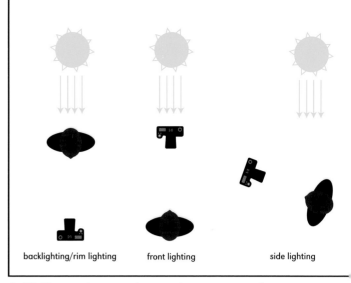

backlighting/rim lighting front lighting side lighting

4-10. You can't move the sun, but you can adjust your subject's and camera's position relative to it. This allows you to control the direction of the light.

Let's consider an example. The little sweetheart shown in **image 4-11** was absolutely content running along the water's edge at sunset in her perfect white dress. When I saw the gleeful smile she was giving her mom behind me as she hurried to catch her dad and sister ahead, I knew I had to capture it.

The setting sun was low behind her and gently lit up the water in the background with a pinkish, golden glow. I metered for her angelic face, since it was the most important part of the image. This brightened the background around her to make the final result a clean and happy portrait.

4-11. With the sun low behind my subject, I metered for her face. This brightened the background for a clean, happy look.

f/2.8, ¹/₁₆₀ second, ISO 200

Immediately after she passed me by, I swung around and put the sun behind me to capture **image 4-12**, an adorable scene of the twin sisters chasing their daddy along the water. The sunset created a beautiful warm glow and perfectly highlighted the aqua waters of the Gulf. I quickly metered again for the girls and made sure my shutter speed was fast enough to capture their steps and create an image of a family in action.

Front Lighting. Front lighting, as we saw in **image 4-12**, is just what it sounds like: light that is directed at the front of your model (meaning that it comes from *behind* you). Front lighting can look sunny and colorful, but if it is too bright or intense it can wash out your model and their surroundings. Front lighting is more appealing when the sun is at a low angle (closer to sunrise or sunset, which we will talk about more in chapter 5).

4-12 *(above)*. Lit from the front, this portrait has a beautiful, warm glow.

f/5.6, ¹/₁₀₀ second, ISO 200

4-13 *(facing page)*. Kim has great skin that could withstand the harsh front light. It made her eyes stand out in this black & white image.

f/3.5, ¹/₂₀₀₀ second, ISO 200

In **image 4-13**, I knew I wanted to create some crisp and bright black & white images—and this model had the kind of amazing skin that would be able to withstand harsh front lighting and still look luminous. The wet hair with just a bit of sand provided enough interest to keep the black & white conversion from being boring, and her piercing eyes simply shine—with or without color.

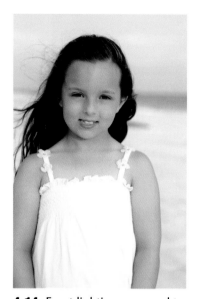
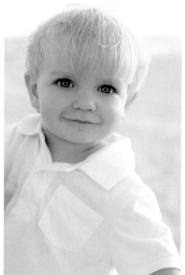

4-14. Front lighting was used to create a simple, sunny look.

f/3.5, ¹⁄₆₄₀ second, ISO 160

4-15 *(left)*, **4-16** *(right)*. Side lighting created a halo on these angelic faces.

4-15: f/4, ¹⁄₁₆₀ second, ISO 160, 4-16: f/4.5, ¹⁄₁₆₀ second, ISO 160

In **image 4-14**, front lighting from the setting sun illuminated this little girl's pretty face and looks crisp and clean against the blue sky and water. I wanted a simple, sunny portrait to highlight how open and innocent she was on this day, without any stylized posing to interfere. Since this girl was so young, we didn't have to worry about the sun badly highlighting any skin imperfections—but full frontal sun without a scrim isn't flattering to everyone.

Side Lighting. Side lighting is simple to achieve when the sun is lower in the sky in both the morning and evening, and it's perfect for portraits. When you place your models with the sun to one side, you are using side lighting. This creates nice shadows on the face and can make an interesting portrait. If the shadows on one side are too harsh, add a reflector (see page 16) or turn your model so that the light hits them from a shallower angle (a little more toward the front of the face). **Images 4-15** and **4-16** show side lighting in practice.

Backlighting. Backlighting has become more popular recently and can produce some amazing images. Everything is awash in pretty, bright light and it lends an angelic, light, airy feel to portraits. For backlighting, you are shooting into the sun with the model between you and the light source. You can achieve backlighting when the sky is super sunny or cloudy but still fairly bright, when your model is framed by a bright window, or when you are shooting a model from below with only the sky behind them. This works particularly well when the sun is lower on the horizon, as overhead lighting can cast shadows that are unflattering or make your image extremely hazy. (If you like the super-hazy look, go for it for a few shots—but you probably don't want to give a client a gallery full of overly hazy images.) When the sun is

low in the morning, the effect tends to be softer and cooler compared to the late afternoon glow, which is typically warmer, at least where I live in the South. **Images 4-17** through **4-20** (this page and next page) show backlighting in practice.

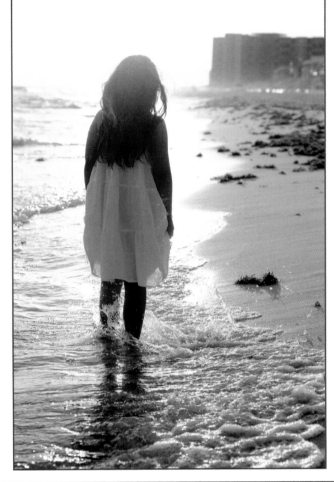

4-17 *(right)*. I shot straight into the brightly setting sun to create this sun-drenched image of a little girl walking in the surf. The soft glow around her, the haze of the buildings in the background, and the foamy surf at her feet made a quietly sweet and meaningful image. I metered for the girl and let the sun overpower the top half of the image.

f/4, $^1\!/_{2000}$ second, ISO 160

4-18 *(below)*. This family was full of energy, so I asked them to do a jump in front of a gorgeous sunset. I wanted to keep the colors of the sky and water but not completely silhouette the family, so I metered for the clouds on the left and then bumped up the exposure to make sure the family was still visible.

f/4, $^1\!/_{320}$ second, ISO 320

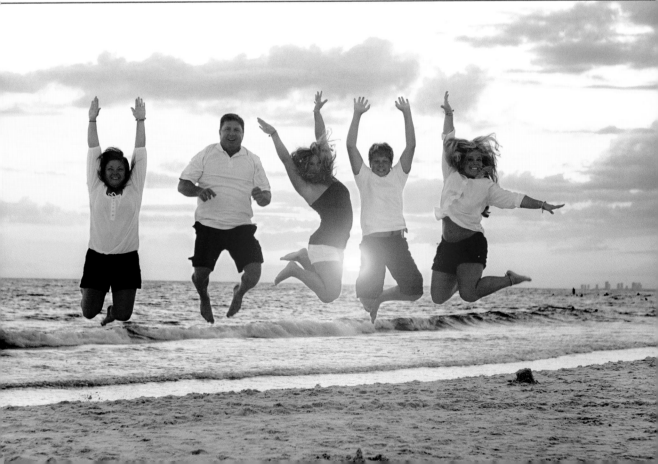

4-19 *(right).* A gorgeous young woman shows off her engagement ring as her new fiancé gives her a kiss. Putting the sun behind and to the left of the man cast golden light on his hair and softened both of their faces. I metered off her ring in perfectly even light to ensure it remained the focus of the image.

f/2.8, ¹/₁₆₀ second, ISO 160

4-20 *(below).* Three tiny girls giggled on the beach together as the setting sun behind them wrapped them in a golden glow and highlighted the ruffles on their dresses. I metered for the dresses to keep their true colors and let the sky go bright.

f/5.6, ¹/₁₂₅₀ second, ISO 320

Rim Lighting. When the sun is low enough in the sky, you get a pretty glow around your model, which is called rim lighting. At the right angle, this rim lighting can make a dramatic portrait. The golden glow gently illuminates stray hairs, makes eyelashes pop, and can add a carefree look to profiles—so really play around with your poses in this kind of light to find what best accentuates your model.

I shoot rim-lit images at sunset with wide-open apertures because I love how the shallow depth of field puts all the emphasis on my model, blurring out any distractions in the background. If you are shooting during the golden hour (see chapter 5) and you have your model between yourself and the sun, adjust your position and angle until you see this glow, usually on their hair. However, be careful not to overexpose if your model has very light or blond hair; it can easily appear that some of their hair is missing if the highlights are blown out.

In **images 4-21** and **4-22**, a beautiful couple enjoyed their walk back from an abandoned pier as the sun set brightly behind them and turned the water golden. A bit of rim light frames the man along his hat and shines in the woman's hair and on her profile. I had been focusing on their daughter and her family to my left, so I didn't have time to turn my reflector to face them as they approached me, but their natural beauty and joy as they walked were too good not to capture. Without a reflector, your models' faces

"Play around with your poses in this kind of light to find what best accentuates your model."

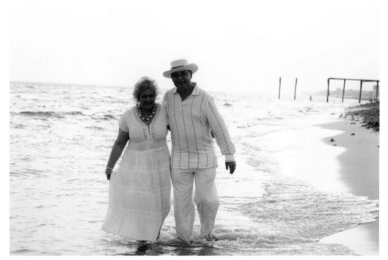

4-21, 4-22. Rim lighting shines along the man's hat and on the woman's hair and profile.

f/5.6, 1/160 second, ISO 125

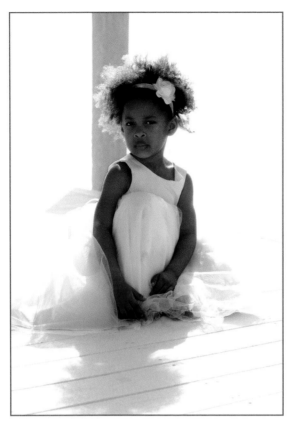

4-23. Adding a reflector kept her face from being lost in shadow in this backlit portrait.

f/5, ¹/₂₅₀ second, ISO 125

4-24. Rim light perfectly highlighted this little angel's blond curls.

f/4.5, ¹/₃₂₀ second, ISO 320

A Reflector with Backlighting

Don't be afraid to bring out that handy reflector when shooting these backlit images. Backlighting with a reflector gives you rim lighting on the hair, eliminates some of the shadows on the face (particularly under the eyes), and adds nice catchlights to help the eyes sparkle. This is useful if you don't want to completely blow out your background and keep your colors a bit more saturated straight out of the camera. You won't have to overexpose the image to eliminate those shadows, since your reflector is taking care of that for you.

will be a bit darker, since they are brightly backlit. You need to meter as closely as you can for their faces and watch for heavy shadows.

The girl in **image 4-23**, photographed near midday, looks like an angel in her white gown on a sun-drenched pier. The water behind her was a brilliant turquoise, but I felt like it detracted from the image so I purposely blew it out to white. The beautiful gold light in her hair perfectly illuminated all those curls, and a reflector in front of her provided enough light to keep her face and front from falling into the shadows.

If you need yet another reason to master manual mode, backlighting is it. Manual exposure control is pretty much a necessity for these sun-drenched shots. Your camera's automatic modes will want to balance the light evenly across the image and you will lose that bright, airy look—or the metering will expose for all the brightness in your image and leave your model underexposed and bland, even with a reflector.

To properly expose your model while keeping the bright background, carefully meter off your model's face while they block the sun, then position yourself in a location where the rim light is visible and the sun is where you want it in your image. For backlighting, I use either the partial metering mode or the spot metering mode to evaluate *just* the face. Partial metering (which evaluates about 10–15 percent of your frame) works well and is the easier of the two modes to nail the exposure with. You can stand at your shooting position, meter from your model's face, then adjust the exposure as necessary for the look you want. To use the spot metering mode (which evaluates only 1–5 percent of your frame), I tend to go up to my model, fill my frame with as much of their darkest cheek as I can, and then take my reading. This is a bit more precise, but it's also a bit trickier. However, it is helpful when I'm shooting on the Gulf Coast's pure white beaches (**image 4-25**), since the extremely bright surfaces tend to interfere with metering in the other modes. If you are surrounded by a bright white beach, snow, or something like water that is extremely reflective, you might want to switch over to the spot metering mode, as well.

Open Shade

Open shade is the safest and easiest lighting situation for portraits. The light is soft and even, flattering and bright, but without glaring or causing squinty eyes. You can find it anywhere

4-25. Sparkling sunlight framed this little girl on the beach as she looked for shells. Shooting low provided an engaging view, and spot metering for her in the golden glow of sunset allowed me to keep all the radiant colors of the water, the sun, and the glittering shells at her feet. I metered for her and then bumped my aperture slightly higher to prevent it from being too bright.

f/4.5, $^1/_{2520}$ second, ISO 200

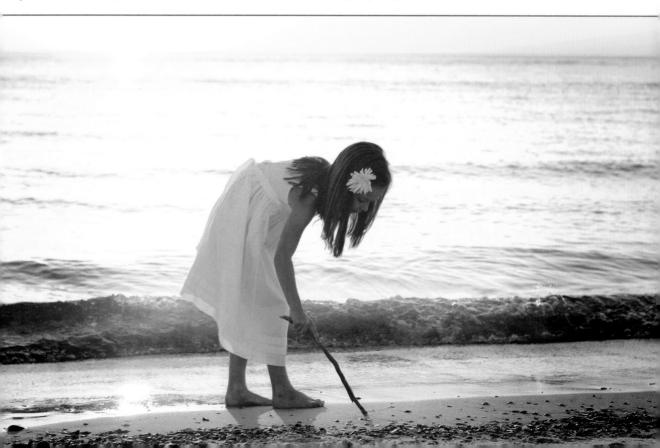

you are outdoors and it is especially useful during the middle of the day when the sun is bearing straight down and bright. Look for a hard line of shadow next to an area of light and voilà! Place your model fully in the shade, at the edge of this line, and have them face into the light. The light will be reflected back up into their face and eyes, illuminating their skin tones and producing nice catchlights.

Meter for your model's face, make sure their face is tilted enough to be able to see catchlights in their eyes, and snap away. The great bonus

4-26. The open shade in a corner of an outdoor mall provided soft, even lighting.

f/3.5, ¹/₁₂₅ second, ISO 200

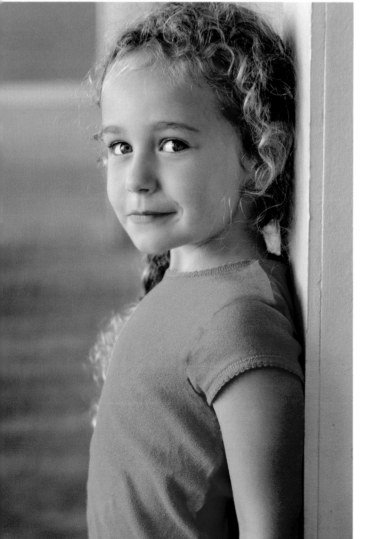

▣ **Open Shade**
The lighting found in an area of shade immediately adjacent to an area fully lit by direct sun.

▣ **Catchlights**
Direct reflections of a light source on the subject's eyes. These bright white areas give the eyes some sparkle and life.

with open shade is that when you meter for your model, whatever is further into the shade behind them will get slightly darker, placing even more emphasis on them. If there are any bright areas behind your model, those will be blown out and can either add to or detract from your image, depending on how large they are and where they are placed in the composition. Keep an eye on these bright spots to make sure you are achieving the look you want. I typically try to shoot against a darker background to keep the emphasis on my model.

"Keep an eye on these bright spots to make sure you are achieving the look you want."

Let's look at a few examples of how portraits can be created using open shade. **Image 4-26** was created as we were coming to the end of a head shot session. The sun was quite bright and we could no longer shoot outside, so we moved into an open corridor at an outdoor mall for a bit more shade. There, we found a corner with open shade that provided perfectly soft, even lighting on her beautiful face and lit up her eyes.

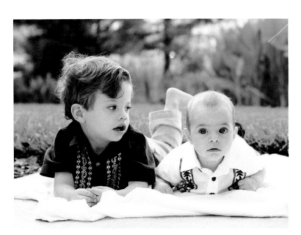

4-27. Open shade from nearby trees and an open breezeway made for a nice image.

f/4.5, ¹/₁₂₅ second, ISO 200

For **image 4-27**, open shade from nearby trees and an open breezeway allowed me to place the baby outside for a few individual pictures—until his big brother decided he wanted in on them, too. I loved the look he was giving his baby brother and grabbed the image. Even though the white blanket is a bit too bright, it's still a sweet moment.

For **image 4-28**, we were just wrapping up an early morning swimwear session on the beach and the sun was a bit too high to shoot without shade or a scrim. At a nearby boardwalk, a raised porch provided the perfect amount of shade from the direct sun. It allowed us to grab a few more shots, including this one. Behind the model, typical beach debris, seaweed, and unattractive beach grasses were visible. You could also see the foundation for the house the porch was attached to. A shallow depth of field was paired with a tight crop to eliminate all these unpleasant distractions, leaving nothing but the amazing model.

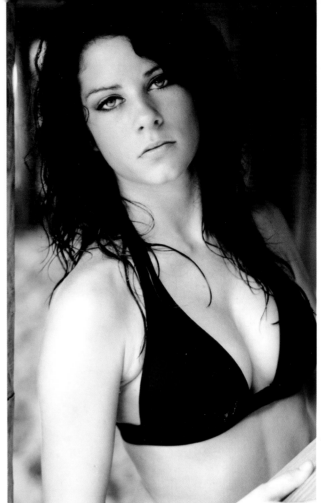

4-28. Working in open shade, a tight crop and shallow depth of field were used to control the background and keep the emphasis on the subject.

f/2.5, ¹/₁₂₅ second, ISO 200

Dappled Light

Dappled light is what happens when the sun is shining through an object that blocks portions of it, leaving little spots of light shining in through the shade. If you've ever taken shelter

> **Dappled Light**
> The variegated lighting found in an area of shade where openings in the shade-producing obstruction allow beams of direct light to shine through.

created by airy sculptures, window panes and blinds, porch slats, and other kinds of partial light obstructions.

"Meter from your model's face and let the shadows fall off into darkness for drama."

Dappled light looks beautiful in person, little shapes of light sparkling all over . . . but in portrait photography it can be extremely distracting and is almost always to be avoided. If you are under tree branches and see this dappled light hitting your model, turn their face away from it so that it falls behind them or use the trunk of the tree to provide even shade. I place my models at the edge of the shade, just before the dappled lighting begins, to enjoy the benefits of the light coming down without having any of it actually hit their face directly. Alternately, you can try to use your reflector to overpower the bright spots and meter from the face with the reflector in place—if enough light is coming through and you can angle correctly.

If you are feeling creative, you can also try using dappled lighting to highlight certain areas of the subject's face (**image 4-29**), leaving the rest in the shadows. This tends to work best when the light is soft; otherwise, the transition areas (from highlight to shadow) will create hard lines that detract from the face.

Larger areas of dappled light, such as between buildings or roof lines, can be used as a natural spotlight to put the focus right on your model. In this type of lighting, meter from your model's face and let the shadows fall off into

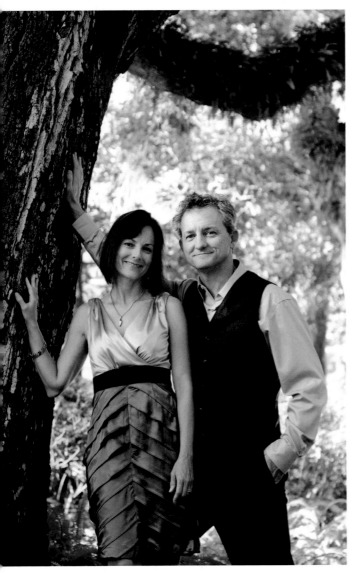

4-29. A beautiful couple posed against an old oak tree, which provided some natural framing. The man had slightly deep-set eyes that tended to shadow, but a fortuitous spot of dappled light provided a little extra glow on his face and kept him out of the shadows.

f/4, ¹/₁₆₀ second, ISO 640

under a tree on a sunny day, you've likely seen dappled light as the sun came down through the branches and leaves. Dappled light can also be

darkness for drama. Try to avoid small spots of light on the face or harsh shadows across the face, as those are the most noticeable and distracting side effects of dappled light. Dappled light that forms patterns, on the other hand, can also be used to add interest to an image—if it is used purposefully.

When I was shooting **image 4-30**, the bright sun was high in the sky as we began the session, so we quickly found some open shade. However, the tiny bit of dappled light coming through the brim of her hat made an interesting pattern so I grabbed a couple of fun shots. I then set up a large white reflector to my right and grabbed **image 4-31**, which brightened her face enough that I was able to properly expose her face and still keep the colors of her sweater and necklace without blowing them out. As you can see in the captions, my settings were the same in each of these images. The only thing that changed was the light from the reflector.

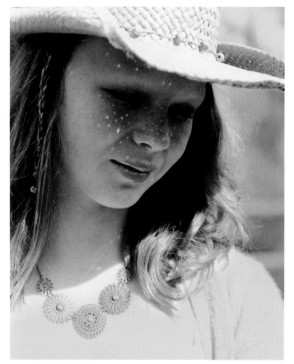

4-30 *(left)*. The dappled light coming through the brim of her hat made an interesting pattern.

f/4, $^1/_{160}$ second, ISO 160

4-31 *(below)*. Adding some reflected fill brightened her face.

f/4, $^1/_{160}$ second, ISO 160

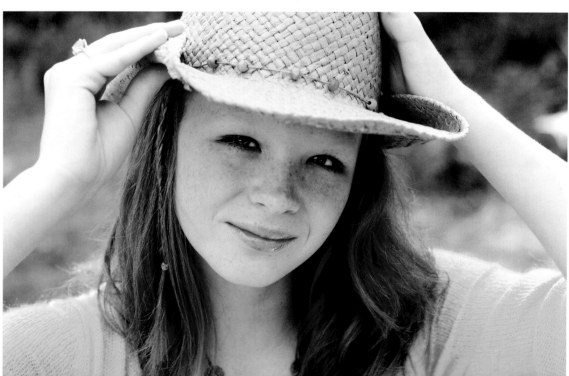

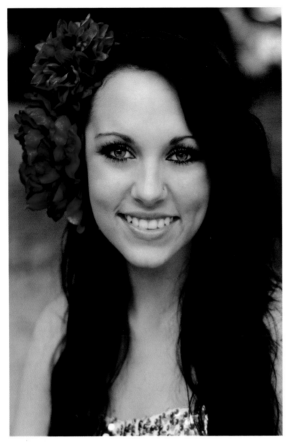

4-32. Diffused, even light from the overcast sky helped create a perfect head shot for this gorgeous young woman. Soft light hides any little skin imperfections and is flattering to everyone.

f/3.2, ¹/₁₆₀ second, ISO 800

4-33. Soft, overcast light glowed around this senior guy as he hung out under a local pier.

f/5, ¹/₂₅₀ second, ISO 100

Overcast Skies

Just because the weather report shows overcast skies doesn't mean you have to stay home. Overcast days are often a godsend, especially when I am shooting on the beaches of the Gulf Coast of Florida. These are often blindingly bright when the full sun is reflecting off all that white sand. The hazy sky can act as a giant, horizon-sized softbox and give you gentle, diffused light that reduces strong glare and harsh shadows. Under this kind of lighting, no one has the squints and the whole location looks as though you are wearing a pair of sunglasses without actually bringing out the Ray Bans. This light is also perfect for enhancing the vivid colors of flowers, skin tones, eyes, and clothing, so use it to its full potential by emphasizing those elements in your composition.

If you nail your exposure, your colors will seem deep and rich right out of the camera.

You'll also see more details in both the highlights and the shadows. Metering for the correct exposure is a bit simpler since the light is fairly even, and you can again use a reflector (or an existing reflective surface nearby) to provide a bit more highlight if you wish. I often use a nice gold reflector to warm up faces and put a bit more light on things if it's really overcast out. This helps to counteract the bluish light, if it is looking sad and gloomy.

The main drawback to overcast days is that the light can be a bit too flat, with very little shadowing to reveal depth or dimension. Some photographers actually *want* flat lighting, but when none of the subject's facial features are highlighted or shadowed to show their contours, it can result in a very boring portrait. To remedy the situation, try positioning your model near a naturally reflective surface where bounced light

"The main drawback to overcast days is that the light can be a bit too flat . . ."

from water, bright rocks, light-colored walls, or even car bumpers can add a needed bit of highlight. You can also use your reflectors to control those highlights and bounce them right where they are needed. Be sure you check for

A Dream Location

One of my favorite state parks, St. Andrews State Park, has amazingly sugar-white sand that, combined with bright sunlight, can easily become overpowering. Shooting in this location on a day with an overcast sky provides soft, even lighting without being so bright that anyone needs to squint. In **image 4-34**, the beautiful turquoise waters of the Gulf of Mexico sparkled in the evening sun, which gently illuminated the amazing blue sky with pinks and oranges. I purposely kept the background colors a bit muted, not only to keep the focus on the family in the foreground, but to keep

the feel of a living watercolor that the evening had in person. In dream locations like this, all you need is a loving family to create a beautiful, timeless portrait. The sailboat in the distance was a sweet bonus.

4-34. A location that tends to be overpowering under bright sunlight sometimes takes on a much nicer look under an overcast sky.

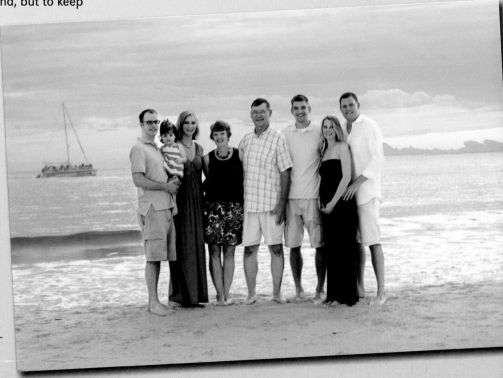

f/4.5, ¹/₁₆₀ second, ISO 200

catchlights in the eyes so they don't look dull and lifeless. Finally, check to ensure you see some highlights along the cheekbones and the nose.

A secondary issue on extremely overcast days is a dull gray sky that can overpower the rest of your image. To solve this, position your model in front of trees, buildings, or some other background that obscures the sky. You can also adjust your shooting angle to exclude it, or simply frame more tightly around your model (**images 4-36** and **4-37**).

Stormy Skies

For beach portraits, nothing makes me more excited than seeing that storms are forecasted close to (but not during) my scheduled photo shoots. It sounds crazy—unless you've seen the amazing skies that storms typically bring with them. Under stormy skies, we usually get all the great diffuse lighting of an overcast day, even during what would normally be a very sunny time of the day. This produces an almost surreal landscape full

QUICK TIP > As the sky gets darker, increase your ISO to be able to keep your colors and whites true to life.

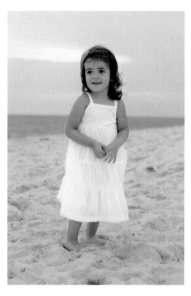

4-35. Blue and pink clouds streaked through a mostly gray sky, while the sun peeked through for a pastel backdrop that was perfect for a little girl.

f/4, ¹/₁₆₀ second, ISO 400

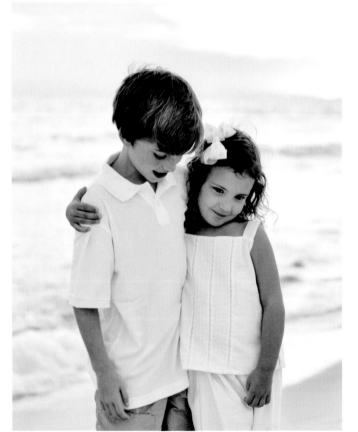

4-36, 4-37. A boring sky surrounded these siblings hugging on the beach. The sky added nothing to the image, so a simple crop changed the orientation to focus on the children.

f/3.5, ¹/₂₀₀ second, ISO 200

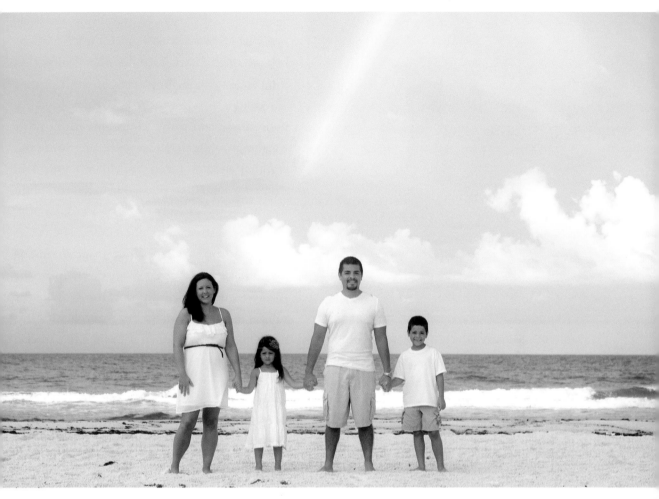

4-38. We didn't let the nearby rain scare us away—and reaped the rewards.

f/7.1, 1/250 second, ISO 160

of drama and enriched colors with lighting that doesn't make models squint. So keep an eye on the weather patterns and don't cancel too early just because a little rain is predicted.

The sunrise portrait session for **image 4-38** almost didn't happen because it had been raining steadily during the few hours before. In fact, it was raining just east of us on the beach when we grabbed these images, which were complet-ed with an amazing rainbow right through the middle of the sky. We wouldn't have been able to capture such a fun family portrait if we had canceled or been scared off by the rain to the east.

Don't Mess with Lightning

Shooting under stormy skies can provide great light, but you do need to cancel your session if lightning is forecasted in your area. You do not want to risk damage to yourself, your equipment, or your clients by working outside during lightning.

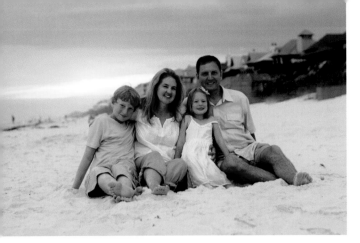

4-39. After the passing of a thunderstorm, we were left with a dramatic sky to use in the background of this family portrait.

f/3.5, ¹/₂₅₀ second, ISO 400

Image 4-39 was created during a sunset session in Rosemary Beach, Florida. The thunderstorms stopped minutes before we were scheduled to begin. Luckily, the Florida heat dried the white sand quickly, but it left a colorful sky for us to work with and the family got a portrait they were proud to display. I shot with a wide aperture since the family was all on the same plane and I wanted to reduce the distractions behind them. I metered for the shadows on their faces to allow for plenty of light.

Raindrops don't stop kids from having a good time—and with a clear umbrella or other weatherproofing materials protecting your camera, they shouldn't stop you either. **Image 4-40** shows my daughter, dressed in a colorful outfit to combat the gloomy weather, attacking puddles on the street near our house. The colors and the action make for a fun image. In **image 4-41**, the light reflected from the rain on the road provided a glowing backdrop for my little subject looking down the road with her back to me. This pose, combined with the light around her, tells a quieter story than the previous shot, so it was converted to black & white to keep the bright colors of her outfit from interfering with the mood.

4-40. Protect your gear, but don't let rain deter you from capturing fun images.

f/2.2, ¹/₁₀₀₀ second, ISO 200

4-41. Converting to black & white helped preserve the quieter mood of this image.

f/2.2, ¹/₁₂₅₀ second, ISO 200

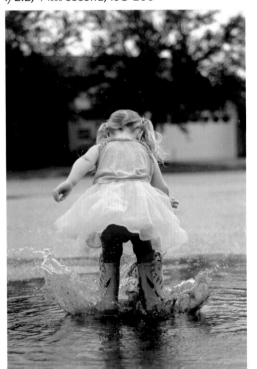

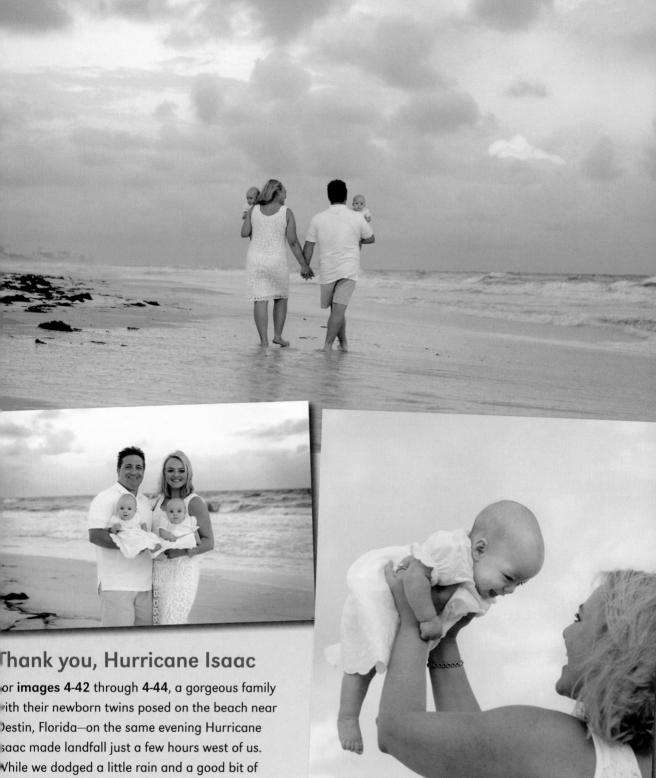

Thank you, Hurricane Isaac

or **images 4-42** through **4-44**, a gorgeous family
ith their newborn twins posed on the beach near
estin, Florida—on the same evening Hurricane
aac made landfall just a few hours west of us.
hile we dodged a little rain and a good bit of
ind, the sky that the storm produced was almost
therworldly and quite beautiful. It made a wonder-
l backdrop for their portraits.

-42, 4-43, 4-44. Hurricane Isaac making landfall a
w hours west of us produced an almost otherworldly
ok in the sky.

/4.5, ¹/₁₆₀ second, ISO 320

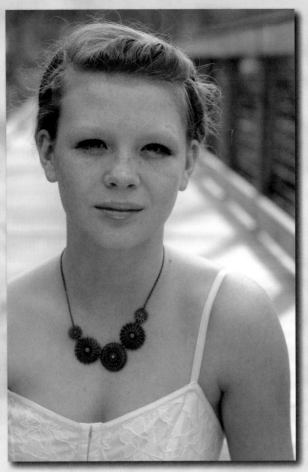

4-45. Backlighting alone resulted in an image that's not very interesting.

f/4.5, ¹/₂₀₀ second, ISO 125

4-46. Adding a gold reflector gave the image some life, but the effect is a little overwhelming.

f/3.5, ¹/₂₅₀ second, ISO 125

Reflected Light

We've already touched on a few circumstances in which reflected light can help you make the most of the existing light without having to resort to the addition of flash or other light sources. Let's take a closer look at the role reflected light can play in your portraiture.

Natural Reflectors. Almost everyone has stood at the shore on a calm day and experienced the intensity of the reflected light. Light reflecting off of water can, in some instances, seem even brighter than direct sunlight itself. Light can also be reflected off windows, light-colored walls, rocks, sand, snow, grass, and just about anything else you can name.

Reflected light is typically soft, but it's important to remember that it will carry with it the color of the material it has bounced from. For example, large expanses of green grass can reflect quite a bit of green light onto your model, causing a green color cast on the skin (especially visible in the shadows).

4-47. Pulling the reflector back from the model just a bit yielded a much nicer look.

f/4, ¹/₂₅₀ second, ISO 125

Portable Reflectors. I don't want to spend a lot of time searching for reflective surfaces, so I always have my 5-in-1 reflector handy. This can be easily angled to fill in the shadows, highlight the cheekbones, and make the eyes sparkle. Pairing backlighting with a reflector gives you dramatic separation from the background along with a brightly lit face, which produces a pretty pleasing portrait. (While you may want a few images of dramatic backlighting that are hazy or more silhouetted in nature, make sure you get at least some that use reflected lighting to give a nice exposure on the face. This creates a well-rounded gallery to show your client.)

> "Pairing backlighting with a reflector gives you dramatic separation from the background."

Let's look at how it's done. **Image 4-45** was shot in the late afternoon, and the subject faced away from the sun to avoid squinting. It is exposed well, but it's flat and uninteresting. There is no light in the eyes or highlighting on the features. For **image 4-46**, I added a gold reflector for fill and to warm up her porcelain skin. You can see how the reflected light puts life back in her eyes and highlights the nose, chin, and cheekbones. Still, it's a little overwhelming. Pulling the reflector back from the model just a bit (**image 4-47**) maintained the nice warm light on her face and upper body without overpowering her. Now she is well lit, with nice light on her eyes and features. The sun behind her to the right provides a nice rim light.

When choosing a location, take note of what is surrounding it. Large buildings nearby may provide a great reflective surface and allow you to use locations you might otherwise think too dim. The larger the item doing the reflecting, the more light will be available.

While environmental reflectors are handy, they are obviously less portable than the reflector in your location lighting kit. Usually, they can't be moved at all, so you'll have to position your model where the reflected light hits.

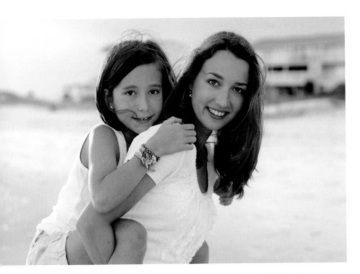

4-48. Adding a white reflector for fill (rather than overexposing slightly to open up the shadows) let me keep more of the dreamy beach background and sparkling water for context.

f/3.5, ¹/₁₆₀ second, ISO 125

Image **4-48**, an image of two sisters, was created with the warm glow of sunset backlighting their hair for a bit of rim light. I added a white reflector to bump up the light on their faces, then exposed for the darkest shadows on their faces. With the additional light from the

▥ Lens Flare
When direct light hits the front of the lens, creating a geometric pattern of bright highlights and/or a hazy look over some or all of the frame.

Postproduction

I like the warm, artistic, carefree feel of lens flare images straight out of the camera, so my post-processing treatment is modest. I increase the contrast a bit to pull some detail back in my shadows (either with the sliders in Lightroom or with the Curves tool in Photoshop). If necessary, I warm up the color a bit to make sure the image looks as sunny and happy as the moment felt.

reflector opening up the shadows, I was able to keep more of the dreamy beach background and sparkling water for context. This lets viewers know that these two girls were playing in the sand along the water's edge. If I had used only the existing light and overexposed slightly to get the shadow areas to the level seen here, those background details would have been lost.

Lens Flare

A little bonus with backlighting at sunset and sunrise is interesting lens flare. Traditionally, this is considered a flaw, but it can be an artistic addition to enhance the look of certain images. Lens flare is a fad that comes and goes, but you can add it sparingly to enjoy the artsy feel it gives images. As long as not *every* image is full of flare, it's fun to dabble in. For best results, keep the sun to one side of your composition, or in a corner, unless the sun is your subject or you are creating a silhouette. The brightness tends to overpower the model if the sun is prominently featured in your composition.

When shooting into the sun, never look directly at the sun. Even through your viewfinder, this can damage your eyes. For lens flare images, I like to start by getting in close to my model to spot meter off of their face, then I back up to frame them the way I want the image to be. This ensures that my model will be perfectly exposed, although it may mean that the background will be a little overexposed. That is sometimes okay; it puts the emphasis on the model and minimizes background distractions. You probably don't want to have an entire session of nothing but bright, blown-out backgrounds, but capturing a few shots like this can add some variety.

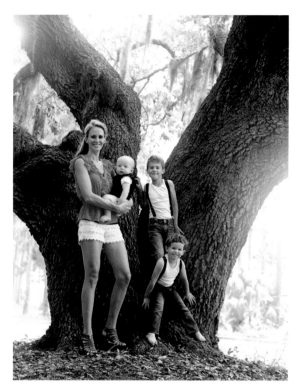

4-49. A stunning mom and her three sons amidst old oak trees made for many beautiful images. We knew the sun would be peeking through from behind this great tree, so I placed the family in the open shade of its trunk. I got a little bit of lens flare, but it only added to the fun.

f/4, ¹/₁₂₅ second, ISO 400

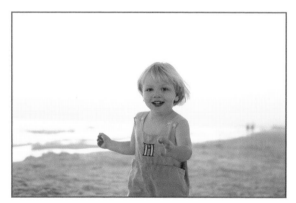

4-50. I had plenty of images of the family with correct exposures, so as the sun was setting to the left of the frame, I spot metered for the boy's face and then took a few quick shots as he ran toward me. Blowing out the background put the focus right on him and took care of the unattractive seaweed along the beach, giving me a crisp, clean image of a toddler doing what toddlers do best: playing.

f/3.5, ¹/₃₂₀ second, ISO 250

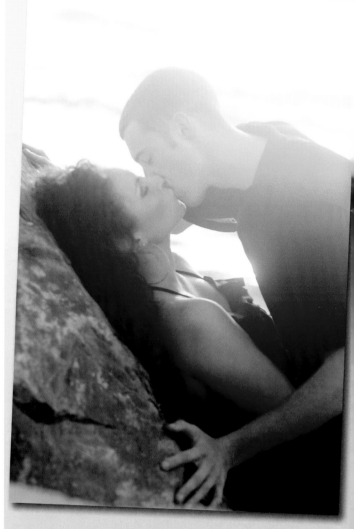

A Romantic Moment

This session concluded a surprise engagement, so I made sure to capture a few romantic images for them. As they posed against a large rock by the water, the sun was setting directly behind the man's back and produced quite a bit of flare and haze. I grabbed this shot and then adjusted my position and settings for a few more of the same pose without the haze. I like to offer some variety in my galleries so that my clients have an interesting set from which to select their favorites.

4-51. The dreamy haze of lens flare helped capture the romantic feel of this moment.

f/3.2, ¹/₁₂₅ second, ISO 160

5. Twelve Hours of Shooting

LEARNING OBJECTIVES
- ◈ *Make the most of golden-hour sessions*
- ◈ *Create great portraits in problematic midday lighting*
- ◈ *Adapt your approach for morning, evening, and sunset sessions*

*I*n the previous chapter, we looked at how the amount of light, quality of light (whether it's hard or soft), and direction of light will affect the look of your portraits. As we saw, one way to control this is through positioning the subject in or near shaded areas—or by taking advantage of different weather conditions, when clouds naturally diffuse the direct sun. At the start of the chapter, however, I noted another factor that plays a huge role in the look of outdoor lighting: time of day. Let's take a look at how *when* you shoot will affect your lighting.

> ▦ **Golden Hour (or Magic Hour)**
> The hour just after sunrise (or just before sunset) when the low angle of the sun produces light that is especially appealing on both human subjects and outdoor backgrounds.

Sunrise

We've all heard about the golden hour or "magic hour," that hour after sunrise (or before sunset) when the low angle of the sun results in light that is soft and diffused instead of harsh and unflattering. Its warm glow naturally brings out the lush colors of the landscape and flatters skin tones. As a bonus, outdoor locations are typically not quite as crowded at this time of day, which means less traffic in your image. The golden hour can be used for just about any outdoor photography.

It might seem insane to leave your soft, warm bed before dawn and sit in the pre-dawn chill to capture portraits you feel confident you could produce at any time of the day . . . until you see

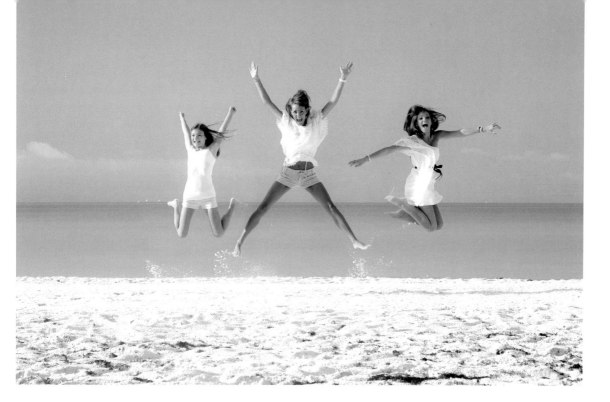

5-1. These three beauties left the comfort of bed at 6AM in order to fit in a sunrise portrait session—and even managed enough energy to give me a gymnastics-worthy jump above the colorful water. Waking up this early allowed us to shoot on a beach before the sun was too overpowering to keep our eyes open. The soft colors just after dawn made a beautiful backdrop for this image. This beach is quite busy during the rest of the day, so coming this early also meant we had the area to ourselves.

f/7.1, ¹/₅₀₀ second, ISO 200

usually fairly blue and unflattering to skin tones but as the sun begins to rise, the warm oranges and reds emerge to balance with the cool blues still left in the sky and produce some of the most flattering light of the day. Because the early morning light is not overpoweringly bright, your models won't squint, no matter which way you turn them, allowing you to use literally 360 degrees of your background without concern.

the results for yourself. As much as I begrudge losing some sleep, or the feeling that the rest of my day is dragging on for what seems like an interminably long time, I eagerly book sunrise sessions for portraits with any early-bird clients that are crazy enough to let me (**image 5-1**).

 Light on the Subject. I use the few minutes before dawn to warm up my models, showing them how I will pose them and chatting to get them relaxed and open. The light at this time is

Be Prepared

Pack and prepare the evening before the session. Unless you are used to getting up well before dawn, it's easy to forget something vital (like lenses, camera batteries, or coffee) when you're stumbling around in the dark. If you have to walk to your destination, don't forget a flashlight—so you're not *literally* stumbling around in the dark on the way to your session. Make sure you know what time sunrise actually happens (it changes daily and varies by location) by checking the Internet or grabbing one of those handy sunrise/sunset apps for your phone. Know where you're heading, arrive at least 10 minutes *before* sunrise to make sure you don't miss anything, and have your bag and supplies ready to go.

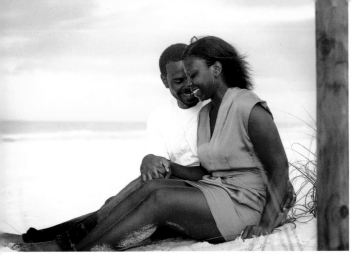

5-2. Soft, hazy light can be extremely flattering, making the skin look soft and luminous. I met this gorgeous couple at 6AM to begin their session, and it was worth every minute of sleep we lost.

f/4.5, ¹/₁₆₀ second, ISO 200

5-3. This family posed in the light just after sunrise. When your location is surrounded by reflective white sand, you have to begin your sessions immediately after sunrise—before the light becomes too bright to see without squinting.

f/5.6, ¹/₄₀₀ second, ISO 125

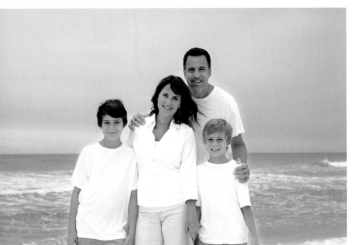

Colors are deep and rich and the side lighting provides the perfect angle for portraits (**image 5-2**). Here's an opportunity to grab some front-light images; turn your model to face the light and grab those catchlights.

Exposure Settings. While the aperture priority mode would work fairly well in the changing light of sunrise, I still encourage you to shoot these scenes in manual mode. With practice, it takes less than a second to flip your camera's settings to capture exactly the light you want—as opposed to allowing your camera to make even the shutter speed automated. Also, as you relocate your model within the light you will want full control over what you are allowing in.

As the sun rises and brightens, underexpose your background slightly to retain the colors, then pull out your reflector to keep the face nicely lit. You can slightly overexpose a few of the images for variety's sake, washing out the background, but be careful not to overdo it. A ⅓ stop overexposure is typically all that's needed for a pleasingly bright image and background, without losing too much subject detail.

Morning

If you can't make it to sunrise and the first golden hour but still want to get portraits done before the heat of the day, 8–10AM is the perfect window. The sun is still fairly low in the sky and will come in from the side for a nice directional look. It is bright enough to illuminate your

Light on the Background

Remember that your background is likely getting the same flattering treatment as your subject. If possible, plan your shoot in a wide-open space where the light from the sunrise is not obstructed by buildings or large trees so that you can take full advantage of its beauty. Grass, trees, stretches of beach, and even buildings behind your subject seem to glow beautifully in the early morning minutes of dawn as dew from the night begins to evaporate in the light. This creates a magical, glowing backdrop that is perfect for any portrait, so make sure to capture some shots that include a nice view of the background.

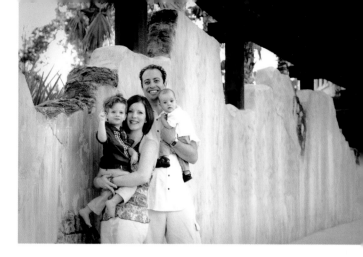

5-4. This family posed for portraits at a picturesque resort, early in the morning before a day at Disney. A quick scan of our surroundings yielded this breezeway, which mimicked the colors of their wardrobe and provided a bit of shade from the morning sun. The high walls blocked most of the light, while the light sidewalk provided ample reflected light for fill.

f/5, ¹/₁₂₅ second, ISO 200

models without making them squint too much (especially if you turn them away from the sun) and it isn't creating harsh shadows yet.

Add a Reflector. With the sun behind the model, position your reflector to help fill in from one side or the other, but avoid reflecting too much light upwards. Particularly while the sun is low, angling your reflector too much from below can up light your model's nose and age them, neither of which are desirable effects.

Exposure Settings. Remember to expose for the darker side of the face to avoid shadows and keep your shutter speed high enough to avoid any motion blur. At this time of the day, your background will be pretty evenly illuminated. If your aperture is too narrow, your model can be lost in a busy background; I prefer to use a wide-open aperture to blur any distractions and keep the emphasis on my model.

Midday

Out in the open, the midday light is hard, overpowering, and directed straight down in a very unflattering way. It accentuates any flaws and

wrinkles and casts harsh shadows on the face and under the eyes. We've all seen pictures of people squinting into too-bright sun that is directly overhead—nobody wants that. But what if the only time your model is available to set up a session with you is around lunchtime? Don't

QUICK TIP > You can have an assistant hold your reflector for you, wrangle it yourself, or clamp it to a tree—or anything else that's free. I've practiced a lot and can usually manage my own reflector (it's good for the arms, too!), but I like to bring clamps to be prepared.

5-5. In these images for a children's clothing boutique, we had multiple models and outfits on a sunny summer day. We began early, but the shooting didn't really start until 9AM. Under the cover of trees, the sun was low enough to not be blinding, but bright enough to bring out these baby blues.

f/5.6, ¹/₁₂₅ second, ISO 160

worry. It is possible to get amazing portraits even with the sun at its peak in the sky.

Find Open Shade. For natural light portraits, midday is the time to look for some open shade (see chapter 4). It provides true colors and nice lighting, plus it's fairly easy to nail the exposure in this lighting situation. It allows your models to shoot outdoor portraits without harsh shadows and squinty faces.

5-6 *(top left).* Under the cover of a porch, close to the edge, I had enough light to light up this little darling's face and produce shadow for contours.

f/3.5, $^1/_{200}$ second, ISO 500

5-7 *(bottom left).* This bride posed under the cover of a pavilion before her outdoor ceremony. The pavilion gave me enough shade from the hard sunlight to capture soft, pretty portraits.

f/3.5, $^1/_{125}$ second, ISO 500

5-8 *(below).* A couple found relief from the hot sun just inside a doorway, which provided us with a warm, brown backdrop. The open doors admitted enough light to expose them properly.

f/3.5, $^1/_{125}$ second, ISO 500

Try a Storytelling Approach

At midday without the cover of some shade, you may want to experiment with your model looking away or down and try to tell a story. Fields of tall grass framed this little girl (**image 5-9**) as the sun neared high noon. The light on her hat and arms was coming almost straight down, creating hard shadows. Rather than have her look up at me, I allowed her to play in the grass and pick leaves so I could focus on the actions and her environment. Later, this little sweetie was belly-laughing at a joke and had to take a break (**images 5-10** and **5-11**). Crouching low in the same spot just a few minutes after the previous image was shot, the darker background allowed me to open the aperture and capture a new perspective.

5-9 *(above).* In the harsh sunlight, a portrait focused on the little girl's activity was the most appealing option.

f/3.5, ¹/2500 second, ISO 160

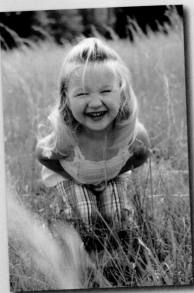 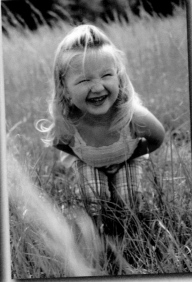

5-10, 5-11 *(left).* When she crouched to laugh, the darker background let me to stop down for a different look.

f/2.8, ¹/2500 second, ISO 160

I stay away from open shade under trees at this time of day, unless the tree canopy is *very* full and provides good coverage. Porches and bridges are better options. Porches are usually ideal for open shade portraits and work well for larger groups. If you have an attractive house behind the porch, even better. Watch the lines behind your models to make sure none of them seem to grow from a head or cut the image in half. Also, use your depth of field to ensure separation between your model and the background. Porches can provide interesting framing for your portrait if you use window lines, doorways, and porch railings to your advantage.

Doorways are also a great place to find open shade. If it's too bright outside and too dark inside, have your model come to a doorway and open the door. You can change the intensity of the light by having them move closer to or farther away from the door. And keep in mind, the larger your light source (subject closer to the door), the softer your shadows will be. The

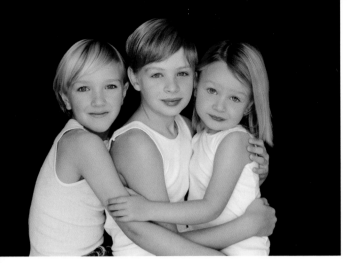

5-12. The bright afternoon sun, an open doorway, and a large black fleece were all I needed to create this portrait.

f/3.5, ¹/₁₂₅ second, ISO 640

smaller your light source (subject farther from the door), the more dramatic the shadows in your image will be. If background clutter is an issue, use a wide-open aperture to minimize it.

The bright afternoon sun, an open doorway, and a large black fleece were all I needed to create **image 5-12**. I wanted a clean, timeless look with the focus on their faces to capture what the kids looked like at that point in their lives— without any distractions. My foyer was not large, only about 6 feet wide and 10 feet long, and I tested the light first with a more willing participant (my husband) to see about how far away from the open door I needed to place the kids while I shot into the space from outside the door. I added a piano bench, some white tank tops, and a black backdrop (clipped to a bookshelf) to hide the living room beyond—and voi-

là! The light is bright but not too harsh—and the portrait, once again, proves that you don't need a fabulous location or fancy equipment to produce wonderful portraits.

Add a Polarizing Filter. Polarizing filters (also called polarizers) can make a huge difference in your results when the sun is high. Polarizers cut down on the amount of reflected light that hits your camera sensor—just the way your nice sunglasses block the glare from your eyes. Have you ever looked down at the water before you put on your polarized lenses? After you slide them on, you realize you can look *through* the surface of the water and see much more than before. Colors also seem more vibrant and intense. Polarizing filters work the same way on your camera. Travel photographers use them all the time to make the sky a beautiful deep blue and to render the water as clear as possible. They will enhance your images, regardless of what outdoor location you are shooting. Polarizers are inexpensive and also help protect the front of your lens from the elements. For the maximum effectiveness when shooting using a polarizer, keep your lens at a 90 degree angle to the sun.

Afternoon

You can shoot in the afternoon in much the same way you would shoot in the morning. The sun isn't quite as intense as it was at noon, so you can venture back outside—especially if there is some

Head to the Garage

Shooting a portrait in a garage seems crazy, but the long, wide doors on garages let in an amazing amount of light and you can even slide the doors partially closed to control the amount of light that streams in. You can eliminate the clutter behind your model by shooting with a wider aperture—but since the outside is so much brighter than the dark shadows of the garage, most of it will be obscured anyway. Driveways are typically bright and reflective, so they provide the perfect surface for creating catchlights. Experiment with your model standing, sitting, and turning at different angles to the door opening to find the best light for your location.

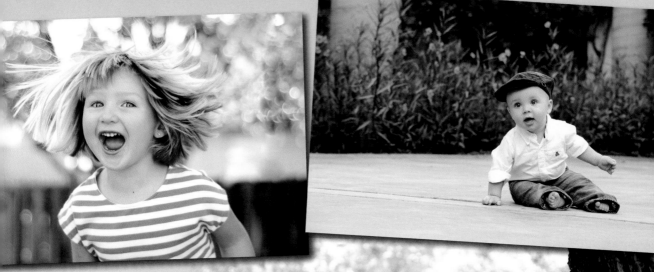

5-13 *(top left).* This image of my daughter was captured while bouncing on a trampoline in our backyard. The late afternoon sun allowed me to capture the vibrant colors of her eyes and dress—and provided enough light for me to use a high shutter speed to capture the action. Four-year-olds aren't known for their ability to sit still, so I learned to adapt to them and capture them doing what they love to do.

f/2.5, ¹/₆₄₀ second, ISO 250

5-14 *(top right).* A gorgeous baby posed on a sidewalk in the late afternoon.

f/5, ¹/₁₂₅ second, ISO 640

5-15 *(right).* When the sun is too bright in the afternoon, the shade of a large tree is a good place to hang out.

f/5, ¹/₁₂₅ second, ISO 200

coverage. Find overhangs, doorways, or the shade of a tree line and shoot away. The afternoon sun is typically warmer in color than early in the morning, so watch your white balance to

5-16 *(top left)*. The husband and wife smiled at each other as they enjoyed a walk down the beach on a windy evening just before sunset.

f/4.5, ¹/₃₂₀ second, ISO 200

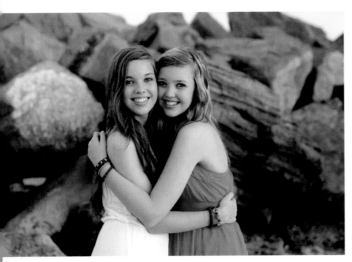

5-17 *(bottom left)*. These sisters posed on the rocks of a state park at sunset, where the warm light kissed their faces and hair. With the sun setting to the right and behind me, the girls were able to look at me without squinting but still got the full effect of the lovely golden glow.

f/3.5, ¹/₁₂₅ second, ISO 200

5-18 *(below)*. A large family gathered on the beach for portraits. The sun setting behind them painted the sky with pinks, oranges, and blues, giving them all a flattering glow.

f/5, ¹/₂₀₀ second, ISO 160

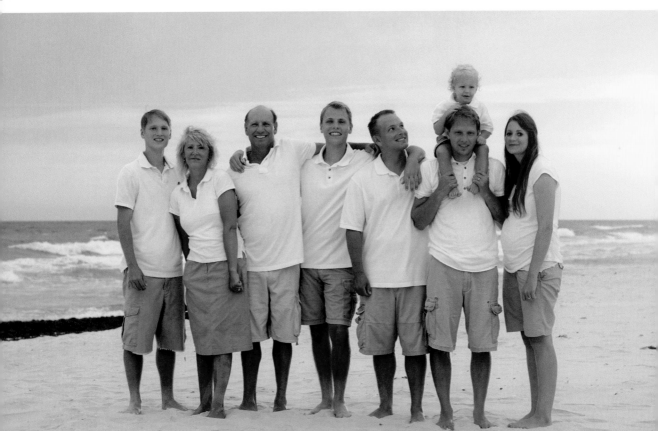

ensure you get accurate coloring. As it lowers, the sun provides more and more side light, so pay attention to where your shadows fall and change subject and camera positions as necessary. Bounce light back with your reflectors to eliminate hard shadows.

Sunset

The second golden hour of the day is, of course, the hour before sunset. It is seriously hard to not take a great picture at this time of the day. Loads of soft, yummy light bathes your model and the scenery in golden warmth that makes everything look sun-kissed. On cloudy or hazier days, you'll get some nice, even front-lighting for portraits. Shoot a few images with your model facing into the sun, working both close up and pulling back to show the golden glow on whatever landscape is behind them. The angle of the sun also provides awesome sidelight opportunities. Turning your subject slightly to the side (relative to the sun) gives you nice contour shadows. As it gets darker or the shadows become too deep, add a small reflector for fill. Take your fill of rim lighting portraits, and throw in a few with lens flare while you're at it.

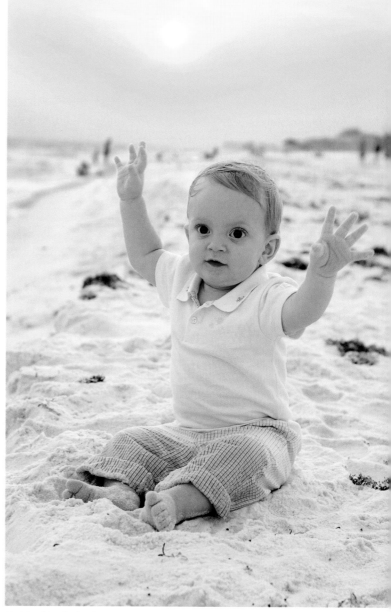

5-19. This baby boy sat on the beach during a perfect golden sunset, showing us "how big" he is with arms stretched high.

f/5.6, ¹/₂₀₀ second, ISO 250

Having the sun sitting low in the sky is perfect for creating full or partial silhouettes. Silhouettes, showing the outline of a face or body, are mysterious, dramatic, and fun in their simplicity. They are also a great way to capture the dramatic colors of sunrise or sunset and can convey a mood or emotion without using expression. Silhouettes are created with backlighting, so position your model between yourself and the sun. Put down your reflector and turn off any flash, then meter off of a bright section of the sky to get your camera settings, which

What to Shoot at Sunset

1. Front-lit portraits (close-ups and wide views to show the beautifully lit background).
2. Side-lit portraits (add a reflector for fill as the sun drops).
3. Rim-lit and lens-flare portraits with your subject's back to the sun.
4. Silhouettes (expose for the sky and let the subject go black).

will underexpose your model. You want the sun low enough to throw the model into shadow, but still bright enough to contrast against them.

To minimize the light, you will likely be shooting with a fast shutter speed and a small aperture. This will keep a lot of the scene in focus, so make sure your background is clean and

QUICK TIP > Silhouettes can be created at sunrise or sunset, but I usually prefer the stronger light and colors of sunset for these images. Play around and see which one you prefer.

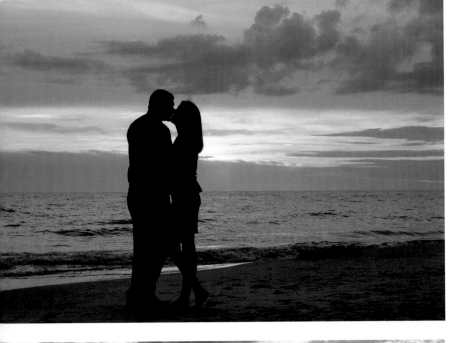

5-20 *(top)*. This couple is close enough together to imply great intimacy, but still far enough apart to have two distinctly separate shapes. I asked them to pause for a moment just before they kissed, which allowed me to grab my shot.

f/7.1, ¹/₂₀₀ second, ISO 500

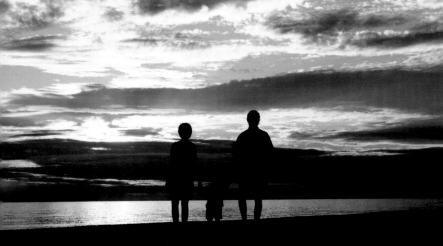

5-21 *(bottom)*. The mother and father held the hands of their little boy as they watched the sun lower behind beautiful clouds. I metered from the brightest part of the sky and adjusted from there. Using a small aperture allowed the sun to overpower the image and created a crisp outline of this family.

f/10, ¹/₁₂₅ second, ISO 125

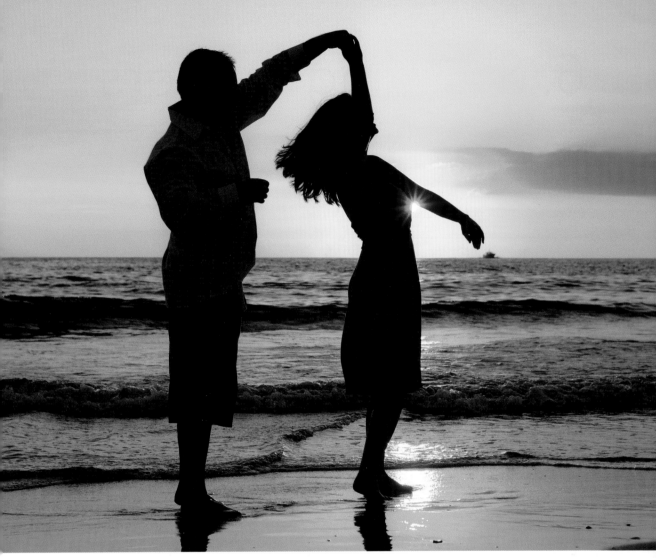

5-22 *(above)*, **5-23** *(right)*. Dramatic sun flare enhanced the romantic moments between these two couples.

5-22: f/4.5, $^1/_{640}$ *second, ISO 200*
5-23: f/6.3, $^1/_{400}$ *second, ISO 200*

uncluttered—and that there aren't any background objects intersecting with your model. You want clean, recognizable shapes in your silhouette, so you have to eliminate any elements that would interfere with or obscure your model's outline.

For silhouette images of the subject in profile, shooting at the subject's eye level will help eliminate distortion—but watch for stray hairs and clothing lines.

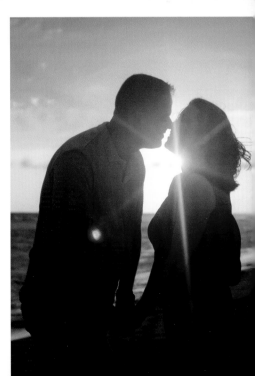

6. Shooting Indoors

LEARNING OBJECTIVES
◆ *Choose appealing backgrounds at clients' homes*
◆ *Find optimal available light indoors*
◆ *Create multiple lighting looks with one window*

There are days when the weather just won't permit shooting outdoors. Extreme heat or cold, rain, and lightning storms all take precedence, no matter who your client is. Therefore, natural-light portrait photographers must learn to shoot indoors, as well. Fortunately, with the increasing popularity of more casual lifestyle portraits, it's no longer necessary to have a full studio available for indoor photo shoots. We have a lot of options.

The Client's Home

I really enjoy shooting portraits right in my clients' homes. People are usually relaxed and comfortable in their own environment, surrounded by things they love. Plus, every home is unique, so the images created there are more personal and significant to my clients than ones shot at the parks or beaches we typically favor.

Setting and Style. To make a great portrait, your clients don't need to have a house or fur-

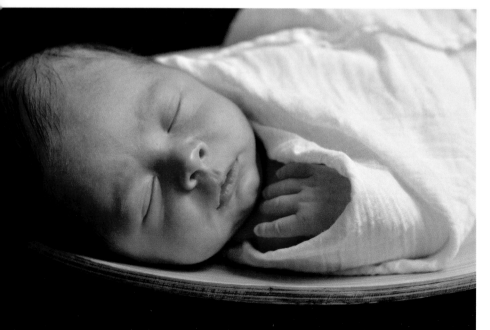

6-1. This simple newborn image was taken on the family's dining room table. The kitchen had two large, long windows that provided the perfect light for his sweet features.

f/4, $1/_{160}$ second, ISO 320

niture from the pages of *Southern Living* or *Architectural Digest*. An interesting arrangement of props and background elements—things that will either be aesthetically pleasing or tell a story—are all you need. I let my clients know that I may need to take a look at all the rooms in the house, so they are prepared. Usually, they have a special room or area in mind where they would like to be photographed. For family por-

> "I always take a peek at other rooms to see if there are interesting spots where I could make a portrait."

traits, this is often the living room. It's where most families spend a great deal of time together, so there are plenty of memories there. It's also large enough to seat everyone comfortably. I shoot these images, but I always take a peek at other rooms to see if there are any interesting spots where I could make a unique portrait.

Watch for clutter and distracting elements that take away from your subjects. If you see potential distractions, use a wide aperture to put emphasis on your subjects. I also ask if I can set aside any knickknacks that might detract from the image. Most people are extremely eager to have the best possible images and don't mind this (and I always put everything back).

Lighting. Asking what direction the majority of the client's windows face before your session will give you a better idea of how the window light will behave and help you plan what time of day will be best for their shoot. Windows facing north are a safe bet most of the day here in the northern hemisphere; the opposite

Capturing Emotions

My little girl had just gotten home from a long hospital stay and wasn't allowed to play outside yet, so she mournfully stood or sat next to a large door, watching her brothers play. I wanted to capture this feeling, with her health still so frail and lots of time spent waiting. Behind her, on the left side of the frame, were a piano and a doorway, neither of which added anything to the composition. Therefore, I exposed for the brightest part of her cheek and let those other items fall into darkness. Every time I see it, I can immediately remember the emotions of that time and it reminds me not to take the happy, carefree days for granted.

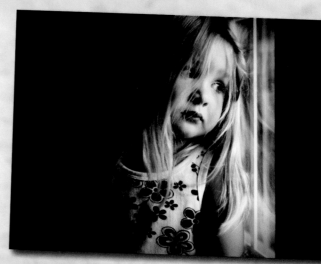

6-2. Behind her to the left were a piano and a doorway, neither of which added anything to the composition—so I exposed for the brightest part of her cheek and let them fall into darkness.

f/1.8, ¹/₁₀₀ second, ISO 640

would be true in the southern hemisphere. Early morning shoots can be done with west-facing windows (or with great care using east-facing windows, as the light will be coming in strongly from the east at that time and may be difficult to control). The opposite will be true at the hours just before sunset.

When you arrive at the home, take a few minutes to assess the available light coming in through the windows and doors. Open up the blinds and the doors to bring more light in. If necessary, I ask if I can move a chair to position it in the best light. Keep watching the light as the day progresses and adjust your camera settings for the amount coming in. Use blinds and sheer or light window drapes to modify the light if it is strong, and don't forget to use *small* windows in your quest for good lighting. The light from a small window can function as a spotlight, shining through the room and creating the perfect spot to position a child.

Play around with positioning the subject. I like to shoot a few images with my model directly in front of the window for a lovely silhouette and show off their form (this is especially

Lifestyle Portraits

Families who crave personal images taken right inside their home typically don't want the stiff, formal poses you might get at a studio. There are no fake backgrounds available and (usually) no velvet settees lying about for them to be artistically draped upon. Particularly with children—and even more particularly with *young* children—traditional "sit up straight with your shoulders angled and head slightly tilted" posing just isn't natural, easy, or fun.

Sessions inside the home are a perfect opportunity to take some lifestyle portraits. Your clients don't always have to be sitting still. Have them read the kids a book, play a board game, snuggle on the couch, or bake some cookies—whatever feels comfortable and natural to them. The key with these personal portraits is emotion, but captured in the most flattering way possible. Shoot from flattering angles and avoid shooting up noses. Keep an eye out for double chins and slouching postures. Even if you have to give small reminders about these, the images will still be much more natural than traditional, formal portraits.

Not only will they relax and look less awkward when you shoot this way, but having a professional portrait of something they love to do together will also be a precious memento.

Window Light and Time of Day

Keep in mind the time of day you are shooting—even indoors! Very bright, sunny days will lead to more concentrated light falling in through your windows and you may need a scrim (such as sheer curtains) to cut down on the glare. You can use your reflector to bounce back some light if needed, or use the black side to cut some light from the window if it's too harsh. Even the *season* may influence the amount of light coming in through the windows.

6-3. This two-year-old sat in front of a group of large windows for a simple portrait. The shadows on the left side of his face outlined his nose and chubby cheeks, while the light from outside brightly highlighted the other side and added catchlights.

f/2.8, $^1/_{160}$ second, ISO 500

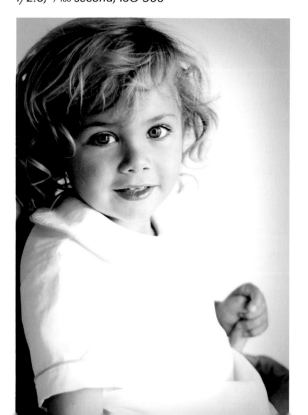

In the Nursery

For newborn sessions, I'm usually in the nursery. New parents are proud of the little personal touches they place in the nursery, and nursery décor is often soothing and photographs beautifully. In nurseries, I open up the windows as far as they will go, prop a large reflector to shine at the darkest corner, and make sure I capture all the details I can using the light that shines through the window. Mothers especially love these sweet captures as they closely reflect what the room looks like in the quiet hours of dawn. The images remind them of what they saw when caring for their baby in those first few weeks.

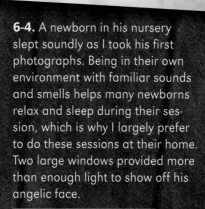

6-4. A newborn in his nursery slept soundly as I took his first photographs. Being in their own environment with familiar sounds and smells helps many newborns relax and sleep during their session, which is why I largely prefer to do these sessions at their home. Two large windows provided more than enough light to show off his angelic face.

f/3.2, ¹/₁₀₀ second, ISO 500

6-5. Chubby cheeks and big, clear eyes are the first things you notice about this little princess—and the light from large patio doors to her right illuminated them perfectly.

f/3.2, ¹/₂₅₀ second, ISO 400

QUICK TIP > Unless you are creating a silhouette, expose for the brightest part of your window-lit model so that you don't blow your highlights and lose detail on the face.

nice with brides). With the model facing away from the window, I like to blow out the background and meter for the face, often with some reflected fill from the walls of the room itself or reflectors I've positioned. Both approaches create attractive results.

It might seem counterintuitive to turn *off* the interior lights inside, but that's generally the best approach. Lamps and over-

head lighting provide *more* light, but it is often at a much different color temperature than the light streaming in from the windows, so it will negatively affect the white balance. If you plan well, there is usually plenty of light from outside to be able to shoot with it exclusively. Keep in mind that shadows are your friend. An issue I see so often with new photographers is that they try to light every corner of the image, not realizing that shadows can help emphasize the key subject. Shooting indoors is a great place to practice this. Unless an interior light specifically illuminates your subject to establish the mood or tell a story, leave the room lights off.

Use the Porch. If it isn't too cold or too hot, and a porch is available, I definitely use it. Even if I am the only one actually on the porch, it gives me another perspective from which to photograph my subject(s). Shooting into open doorways allows lots of light into foyers or sitting rooms and puts me some distance from my clients for a unique look into their lives. For another look, capturing a family on their own doorstep sets a personal mood for images and is usually a client favorite.

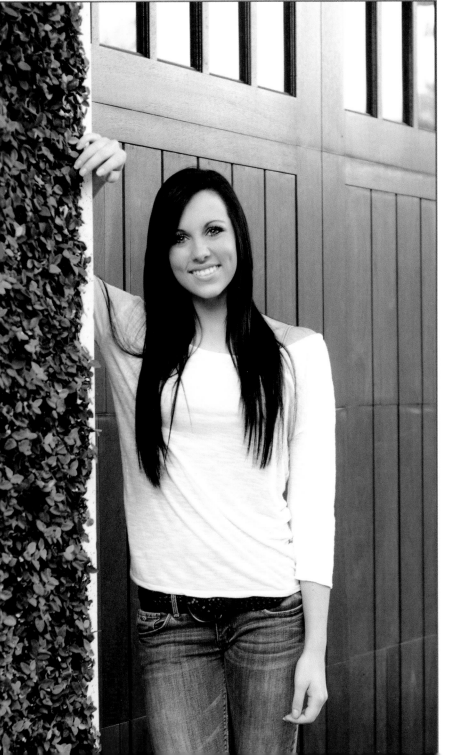

6-6. My beautiful model posed under a porch. The green ivy wall provided a complementary color and the rich brown wood behind her made a nice backdrop for her white sweater and dark hair. The open light highlighted her face without being overpowering.

f/3.5, ¹/125 second, ISO 800

Five Looks, One Window

Whether you are in a home or some other indoor location, if you aren't bringing in artificial light, you will almost exclusively be working with window light. Fortunately, it is easy to get a variety of shots with just one window.

Factors to Consider. A nicely sized window can make a perfect natural softbox. Think of all the great Renaissance portraits you've seen hanging in galleries. Those masters knew that window light can be soft and flattering, naturally enhancing the face to bring out a model's beauty. Again, the larger the window, the softer the light will be—meaning you'll see gentler shadows across the face. Smaller windows mean more direct light, with harsher shadows that can be more dramatic. The closer your model stands to any window, large or small, the brighter the light will be. The farther away from the window they are, the dimmer the light will be on them. You must also take into consideration the angle of your model relative to the window and your own shooting position.

Get Started. To get started, find a nicely sized window in any room—even your own living room. Clear out some of the clutter from both sides of the window, just for simplicity's sake.

Unless you are in a room with multiple windows, your light is going to come from only one side. If you photograph a person with any light source only on one side, you will have shadows on their opposite side, which you can easily overcome with a reflector. Imagine a clock face with your camera positioned at 12 o'clock and your subject sitting in the middle of the dial. You will usually want your light to hit your model from

QUICK TIP > You want to shoot the image as close as possible to the way you would like it to look as a finished product, but it's easier to lighten up slightly underexposed shadows than to recover lost details in overexposed highlights. My preference is to shoot slightly bright, but you will find what works for you and your style.

roughly the 3, 6 or 9 o'clock position. You can use reflectors, bright walls, or other windows (if available) to provide fill for the other side.

Now, track down a willing model who will sit for you. Pay them in beer or cupcakes, if necessary. If you can't locate a model, a baby doll or even teddy bear will work to begin—no cupcakes required. The model I used for this sequence prefers to work for Oreo cookies, but he does a great job of showing how easy it is to create beautiful portraits with little more than the light from a glass-paned door. Since this door is in an entryway, there isn't another window or light source to provide fill.

Look 1: Silhouette. Start by positioning the window directly behind your model—and watch that any framing doesn't cut through him inappropriately. Metering for the light coming through the glass deepens the shadows and throws the profile into a nice silhouette (**images 6-7, 6-8**; *next page*)—if you can get your model to stand still!

Window Light Considerations

1. How large the window is.
2. How far away the window is from the subject.
3. The angle of the subject in relation to the window.
4. The angle of the camera in relation to the window.

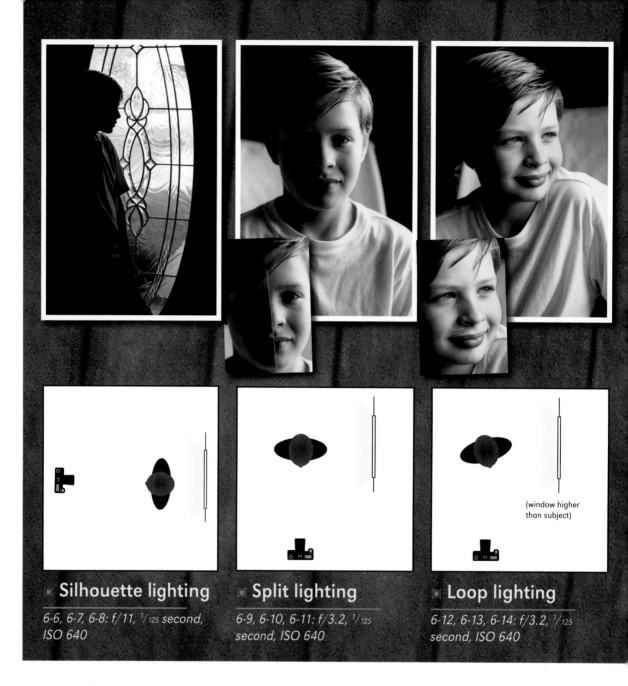

Silhouette lighting
6-6, 6-7, 6-8: f/11, $^1/_{125}$ second, ISO 640

Split lighting
6-9, 6-10, 6-11: f/3.2, $^1/_{125}$ second, ISO 640

Loop lighting
6-12, 6-13, 6-14: f/3.2, $^1/_{125}$ second, ISO 640

(window higher than subject)

Look 2: Split Light. Turn your model at a 90 degree angle from the window and watch how the light falls on the face (**images 6-9, 6-10, 6-11**). If there isn't much light from the opposite side of their face, you will have created split lighting, a pattern where the face is divided into equal halves—one fully in the shadow, one fully in the light. This dramatic pattern is most commonly used on men, as it tends to widen the face, but there's no rule that says you can't also use it on women's faces. If you are photographing with this kind of lighting, meter for the brighter side of the face so that you don't overexpose it, and leave the darker side in shadow.

Look 3: Loop Light. If you situate your model below a high window or have them sit

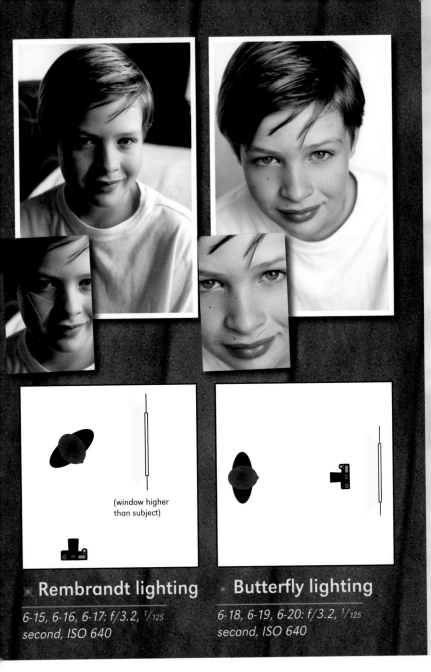

Five Looks, One Window

My son helped me demonstrate these basic lighting patterns by sitting in front of my large office window in the late afternoon.

(window higher than subject)

Rembrandt lighting

6-15, 6-16, 6-17: f/3.2, ¹/₁₂₅ second, ISO 640

Butterfly lighting

6-18, 6-19, 6-20: f/3.2, ¹/₁₂₅ second, ISO 640

on the floor next to a larger window while the sun is high in the sky, the light should be coming in from slightly above them. Have them turn their face slowly toward the window until you see a slight shadow from their nose appear on their cheek. This is the loop-shaped shadow that defines the loop lighting pattern (**images 6-12, 6-13, 6-14**). It is the most common light-

ing used for portraits, as it is flattering on most faces. There is enough light on both sides of the face to see the features clearly, yet some shadow to provide a sense of three-dimensional realism.

Look 4: Rembrandt Light. Turn your model a bit farther away from the window and, again, make sure the light is positioned higher than your model's head. If your window is

very large or tall, you may want to block off the lower portions it so that you only have light from higher up. Turn your model's face until you see a triangle of light on the cheek farther from the window, where the shadow from the nose and the shadow from the cheek are actually touching (**images 6-15**, **6-16**, **6-17**; *previous page*). This is called Rembrandt lighting, because it was used very often by the painter in his works. It is more dramatic than loop lighting and can often be seen as more formal, artistic, or even moody—but it is still fun to use. Not every face can handle Rembrandt lighting, especially if the nose is very flat or the cheeks are very round.

QUICK TIP > If you use a reflector in this situation, make sure that it isn't positioned too low relative to your model. If it is, you will up-light their nose, which is never flattering.

You'll quickly learn to see how different faces respond to these different lighting techniques as you play and experiment.

Look 5: Butterfly Light. Put your back to the window and have your model sit in front of you. All of the light from the window should be falling on their face from above camera height. Notice the slight shadow underneath the nose? You've just created the butterfly lighting pattern (**images 6-18**, **6-19**, **6-20**; *previous page*), which is often used in glamour shoots because it emphasizes cheekbones and de-emphasizes wrinkles (sounds good to me!). Wider faces may not be as flattered with this style lighting, however, so use caution. If you wish, you can position a reflector low under the subject's face to supplement the light.

Broad Light or Short Light

With any of the poses where the face is turned to one side and not centered, you can create broad light or short light on your subject, depending on which one works best for them. Broad lighting (**image 6-21**) is created when the side of the face that is *more* visible to the camera (the "broad" side) is positioned in the light. This means that more of the face is lit, which makes the face look bigger or wider in the portrait. This will work best on a narrower face, as most people do not want to look wide any-where—including their face. Short lighting (**image 6-22**) is the opposite, meaning that the side of the face that is *less* visible to the camera (the "short" side) is in the light. This is slimming and flattering for most people.

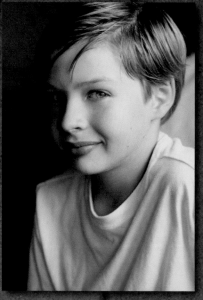

■ **Broad lighting**

6-21: f/4, 1/125 second, ISO 640

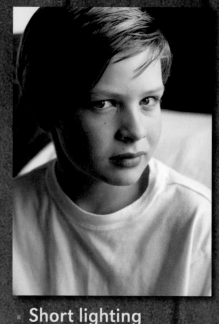

■ **Short lighting**

6-22: f/4, 1/125 second, ISO 640

7. Posing to Flatter

LEARNING OBJECTIVES
Design traditional and lifestyle images ❖
Give effective posing directions to families and children ❖
Increase the variety of your portraits from a session ❖

*P*eople come in all shapes and sizes. Just about anyone can snap a properly exposed image of a person in decent lighting with a shallow depth of field and call it a portrait. True portrait artists look for the best angle for their model's face, the best lighting to mold and sculpt the model's features, and a pose that shows the model's body in the most flattering way possible.

Evaluate the Subject in the Light

Take a moment to walk around your model in each location you are shooting and look at the way the light hits their face. It's not enough to simply have abundant light, you must be able to see where and how the light falls on your model. Find a spot where nice catchlights are visible, where the shadows are appealing, and where the highlights emphasize the subject's features in a flattering way.

Give Clear Direction

It is important to give posing directions in a calm and confident manner so that your models will instinctively listen and follow your guidance. You can practice by giving yourself directions in a full-length mirror. This not only lets you see the difference in various poses (and what looks best), but it also helps you feel the poses so you can demonstrate them while you are shooting. Models often find it easier to mimic your body language than to follow verbal directions.

Lighting Meets Posing

1. In models with prominent brow bones or deep-set eyes, the angle of the light must be low enough to avoid dark, shadowy eye sockets. If you can't adjust the angle of the light, lifting the face relative to the light can solve the problem.
2. Very round faces can be slimmed by posing the subject so that the lighting comes more from the side, putting the edge of the face into a bit of shadow. (See previous page for short lighting.)
3. Narrow or long faces can be rounded by posing the subject so that the lighting falls more on the center of the face. (See previous page for broad lighting.)

Look for Shapes and Lines

We've all seen straight-on mug shots, and we know instinctively that these are designed to give information, not to flatter. Here are some posing tips to help you deliver much more.

Create Asymmetry. You rarely want to photograph a perfectly symmetrical portrait. Asymmetry is one of the keys to an interesting pose.

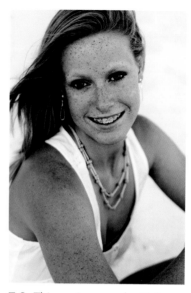

7-1. This cutie struck a fashionable, asymmetrical pose to show off her colorful outfit. You know just by looking that she is full of sass and personality.

f/5, ¹/₅₀₀ second, ISO 500

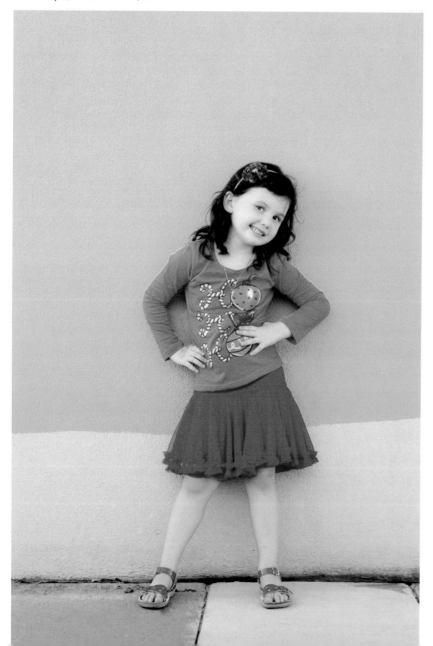

7-2. This senior posed with her arms out to create shapes and an interesting close-up.

f/3.5, ¹/₁₀₀ second, ISO 640

7-3 *(above)*. This adorable young girl made a slight S-curve with her body and legs as she sat on the beach.

f/4, ¹/₁₆₀ second, ISO 160

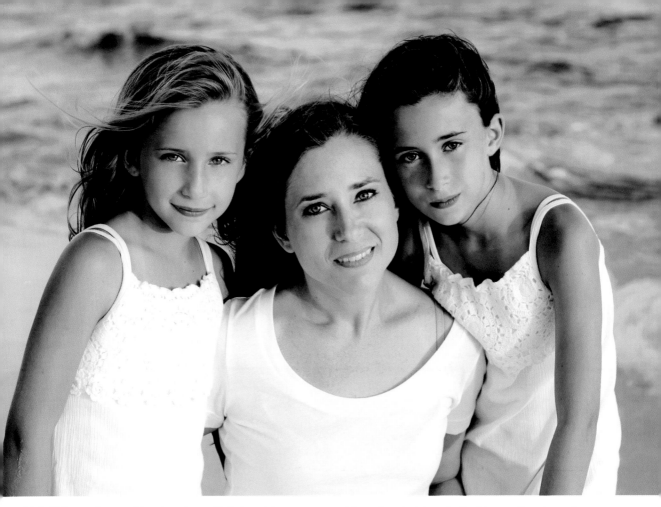

7-4. This mother and her two beautiful daughters are posed in a classic triangle that keeps the viewer's eye moving from face to face.

f/5, ¹/₂₀₀ second, ISO 200

Look for Shapes. Shapes within the composition keep the viewer interested and engaged in the image. Silhouettes make the shapes particularly obvious, but shapes and lines within *any* portrait give structure and depth to your image.

Try directing your model to create shapes with their body. Find ways to create circles, diamonds, curves, and triangles within your image. For example, arms hanging straight and flat against the subject's sides are never flattering, so direct them to bend their elbows and lift their shoulders to create more movement and a beautiful form (**image 7-2**). A diamond shape is produced when the arms are both bent away from the body to emphasize or slim the waist. A circle is created when you pose two people close together, connect their arms and have them lean their heads close together; this keeps the viewer's eye traveling back and forth from person to person. Instructing your model to create an S-curve with their body makes for a flattering and engaging portrait (**image 7-3**). A triangle can be created by posing three faces at different heights (**image 7-4**).

7-5, 7-6. Most people have a slightly slumped posture when they are relaxing (left). Some simple posing adjustments will create a more flattering depiction (right).

f/4, ¹/₂₀₀ second, ISO 400 for both

Watch for Posture. Whether the subject is seated or standing, good posture helps everyone look more presentable. When relaxing, most people slump their shoulders or backs without even realizing it. In **image 7-5** my beautiful young model is sitting casually. For **image 7-6**, I instructed her to sit up straighter, pin her elbows back, and lean her chin down and forward. The result is much more flattering and polished.

Do What Flatters. Women look more feminine when their shoulders are at a bit of an angle; shooting straight on to the shoulders (but still not the face) is usually seen as a more masculine pose. Whether they are standing or sitting, ask the subject to push the largest area of their body (typically the bum) slightly backward; putting it a bit farther from the camera will make it look a bit smaller. With their body at a slight angle to the camera, ask subjects to shift their weight onto their back leg or slightly

Understand Your Client

Asking your clients what images they are most drawn to in your portfolio will give you a sense for what they might be like in person. You can also observe them during the first few minutes you are together, before and during your session, to get a read on their personality types. However, I have found that some clients are on their "best behavior" early in the session, then end up surprising me later when they relax and turn out to be more wild and carefree than I imagined. Typically, the larger the family, the more quickly everyone seems to loosen up and feel comfortable. Regardless of whether I have one model or twenty to shoot, I want them to feel comfortable as quickly as they can so we can create the best images possible.

7-7 *(left)*, **7-8** *(right)*. A beautiful model created flattering angles with her arms and body.

7-7: f/4.5, ¹/₃₂₀ second, ISO 800
7-8: f/4, ¹/₂₀₀ second, ISO 400

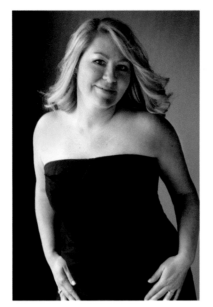 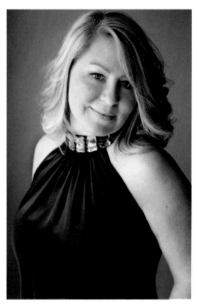

to the side. These adjustments can all be extremely subtle, but they go a long way in making the pose more flattering.

The gorgeous family in **image 7-9** knew exactly how to pose in a flattering way. The daughter, seated, turned her knees away from the camera and placed a hand slightly away from her body to create some nice angles. The mother, standing, kept her arm away from her body to create a diamond shape that makes her waist appear smaller. Finally, the father took a classically masculine pose with his feet spread wide, one leg slightly bent, and his shoulders facing the camera.

7-9. Even on massive rock jetties, this family posed for portrait perfection.

f/4, ¹/₁₂₅ second, ISO 400

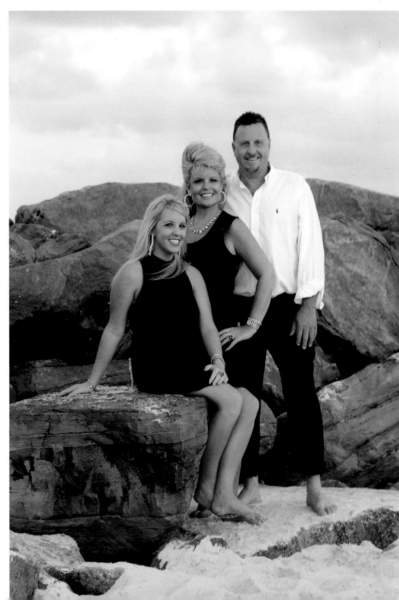

Use Environmental Elements

Environmental elements such as tree branches, doorways, and fencing can be used to help direct the viewer to the main point of the image, to guide their eyes around the image, and to provide interesting framing. Keep an eye out for them on location to add some variety to your images.

With Single Subjects. Particularly when your image features only one subject, including some natural framing or leading lines will prevent the shot from looking too plain or lonely. In **image 7-10**, the boy's pose works perfectly with the tree branches around him, providing framing and interesting shapes. In **image 7-11**, the black iron of the gate mimics the lines in the boy's

7-11. The black iron gate gave the young subject something to interact with, enhancing both the pose and the overall composition.

f/3.2, ¹/₁₂₅ second, ISO 800

7-10. This boy's relaxed and open pose mimicked the tree branches around him.

f/3.2, ¹/₁₂₅ second, ISO 640

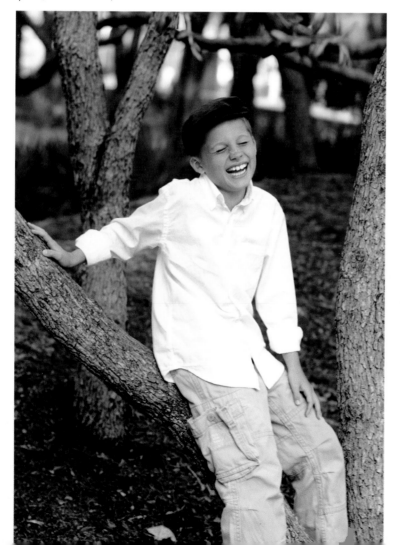

7-12. Tree branches and a white stone path frame this young girl.

f/3.5, ¹/₁₂₅ second, ISO 500

7-13. The lighting, pose, and composition all draw you right into her lovely brown eyes.

f/2.5, ¹/₃₂₀ second, ISO 160

shirt, providing depth of field, leading lines that draw us into the image, and an element for him to interact with while posing. Criss-crossing tree branches and a white stone path frame the young girl in **image 7-12**, leading your eye right to her. An oversized hat frames the cute face in **image 7-13**, creating an interesting portrait that has depth and fun lines. Everything draws you right into her lovely brown eyes.

Solo or Assisted?

I can manage a dozen subjects fairly well by myself—unless they are all children! Families are usually eager to follow direction since they want great images from their session, so I have no problem getting them to take cues. For larger family groups, I prefer to have an assistant with me. My assistant is my second pair of eyes, ensuring that people don't drift too far out of position during formal poses. My assistant also helps me engage children's attention while I'm shooting and will often play with young children while I'm grabbing shots of Mom and Dad solo. To ensure good eye contact and genuine smiles, I want everyone's attention on me when I'm photographing, so my assistant stays close to me and follows my lead. Small and large sessions work much the same way, but with more people to photograph everyone must move a little more quickly. My assistant is there to help smooth those transitions.

7-14. Notice all the leading lines that were incorporated into this *Black Swan*–inspired shot.

f/3.5, ¹/₁₂₅ second, ISO 160

Use Leading Lines. Watch for leading lines within your portrait that you can direct your model to interact with or utilize to keep the focus on your subject. Leading lines can make or break an image, so pay attention to everything that is in your frame. **Image 7-14** was created during a *Black Swan*–inspired concept shoot inside a hollowed-out tree trunk on a lake shore in Florida. The model's diagonal pose within the trunk keeps the eye moving around the image and engaged. The black lines on her costume point up to her face; the lines carved by the decay of the trunk create more leading lines to surround her. A bit of Spanish moss points back down into the center of the image to return us to the beginning.

Created in a simple beach setting, the colorful stripes of the dresses in **image 7-15** provided some easy leading lines for interest. Having both subjects stand in the same position provided repetition within the image—as does

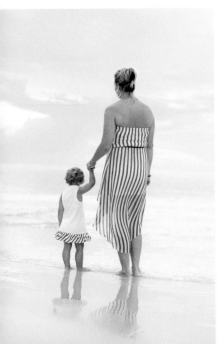

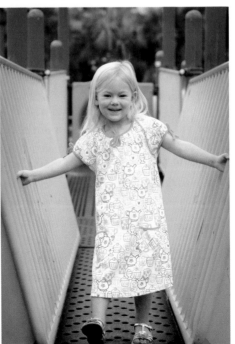

7-15. Leading lines and repetition make this pose and composition successful and appealing.

f/3.2, ¹/₃₂₀ second, ISO 250

7-16. A fun playground photo session provided plenty of interesting backgrounds and leading lines. Here, the yellow bars point directly to her, while her arms point back to the bars. This creates a loop and keeps the viewer inside the image.

f/3.5, ¹/₂₀₀ second, ISO 200

Don't Forget the Hands

Don't forget to pose those hands. Unless you are photographing professional models, most people will not know what to do with their hands. In portraits, the hands should almost never be closed or clenched, as this signals tension. Instead, look for hands that are softly open and relaxed. You can direct subjects to place their hands on their legs, hips, or waist—or to interact with something in their environment. Try to pose the hands last, since they are typically the first thing your model will move, usually without even realizing it.

7-17. My model followed gentle direction to raise her hand near her face, showing off the sleeve for a boutique clothing designer.

f/4.5, ¹/₁₆₀ second, ISO 500

7-18. A pose with the hands under the chin only works with girls or very young children; it looks innocent and slightly feminine.

f/2.8, ¹/₁₆₀ second, ISO 200

the little bit of reflection in the water behind them. For **image 7-16**, a playground provided plenty of interesting backgrounds and leading lines for fun, playful portraits. Here, the yellow bars point directly to her, while her arms point back to the bars. This creates a loop and keeps the viewer's gaze inside the image.

Posing Families

As you practice and study the work of photographers who inspire you, you'll get a sense for what works with different numbers of models.

Pose to Show Relationships. You want the posing to be aesthetically pleasing, but you also want it to represent the relationship between the family members you are shooting. Romantic couples (**images 7-19** through **7-24**; page 100) are typically posed quite differently than siblings. That may seem obvious, but there are other differences to consider. For example, sisters also tend to be posed differently than brothers—especially when they are older teens or adults. Fathers tend to pose playfully with their children (**images 7-25**, **7-26**, and **7-27**; page 101), while portraits of moms and kids tend to be posed more tenderly (**images 7-28**, **7-29**, and **7-30**; page 101).

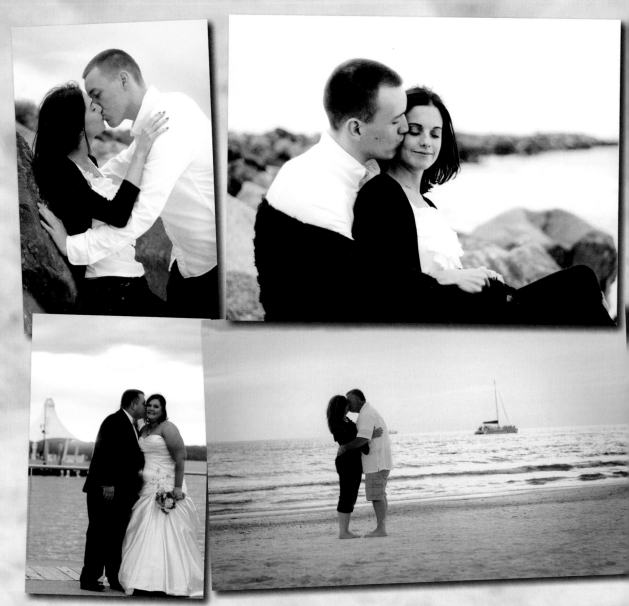

7-19 *(top left)*, **7-20** *(top right)*, **7-21** *(bottom left)*, **7-22** *(bottom right)*. Couples snuggle close or give a kiss to their partner in these portraits illustrating their love. What wonderful mementos these will be for their future grandchildren!

7-19: f/3.2, 1/125 *second*, ISO 640
7-20: f/2.8, 1/100 *second*, ISO 1250
7-21: f/3.5, 1/250 *second*, ISO 1250
7-22: f/3.5, 1/320 *second*, ISO 400

7-23 *(far left)*, **7-24** *(near left)*. These are fun examples of poses for teen couples; they are flirtatious and show the relationship without going too far.

7-23: f/5.6, 1/320 *second*, ISO 125
7-24: f/5, 1/200 *second*, ISO 125

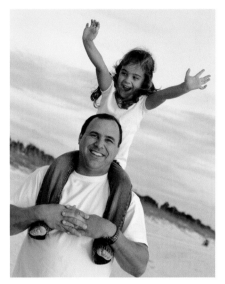

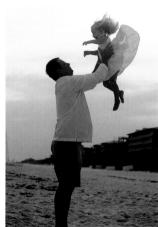

7-25 (above), **7-26** (near right), **7-27** (far right). Fathers tend to pose playfully with their kids.

7-25: f/4.5, ¹/₂₀₀ second, ISO 320
7-26: f/5.6, ¹/₁₂₅ second, ISO 400
7-27: f/4, ¹/₈₀₀ second, ISO 320

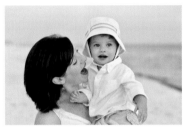

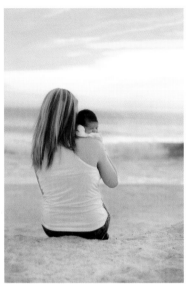

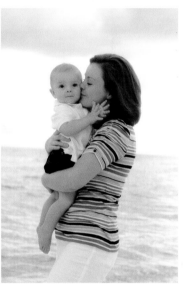

7-28 (above), **7-29** (near right), **7-30** (far right). Mothers tend to embrace their children sweetly for portraits.

7-28: f/2.5, ¹/₂₀₀ second, ISO 160
7-29: f/2.5, ¹/₁₂₅ second, ISO 200
7-30: f/5, ¹/₁₆₀ second, ISO 250

Relaxed and Natural Is the Goal. In a well-done family portrait, your models look relaxed and natural. Some people seem to look this way effortlessly; others constantly worry over what they look like or if their hair is okay and whether or not the children are standing still. The moment I feel one of my subjects is getting a bit too stressed, I take a break from whatever pose we are attempting and have them take a little walk along the beach, or hug their tiny baby, or dance with their kids. Not only does this give them a moment to put the focus back on their family and unwind from the stress of feeling like they need to look "perfect," it

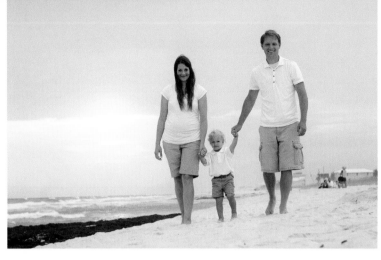

7-31. Amazing colors filled the sky behind this family as they strolled down the beach at sunset.

f/5.6, ¹/₁₆₀ second, ISO 160

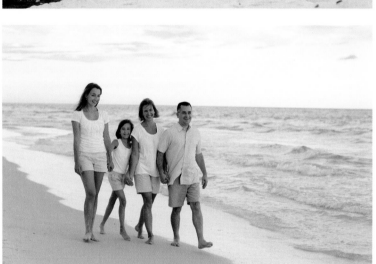

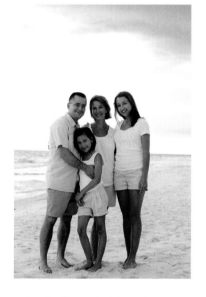

7-32 *(left),* **7-33** *(above).* A family strolled along the water's edge before stopping to smile for my camera in a perfectly harmonious pose that I didn't even have to direct.

7-32: *f/3.5, ¹/₂₅₀ second, ISO 125*
7-34: *f/4, ¹/₃₂₀ second, ISO 125*

QUICK TIP > Take mental notes of some traditionally masculine and feminine poses, as well as some gender-neutral poses. These will come in handy when posing both individuals and families.

allows me to capture some natural interactions. Particularly when photographing families, I love to document the love and sweetness they exhibit when they aren't stressed. Doing something physical for a moment helps people shake off any nervousness they may have about being in front of the camera, and I can reassure them by letting them know I've already gotten some great images before we attempt any particular poses again.

The images from my portfolio that are brought up the most by my clients are the ones in which the family is giving each other a group hug, laughing and playing, dancing, or otherwise being silly. These images are the entire reason some people book me for their family sessions: they want beautiful images of themselves and their family just being happy together. It doesn't matter if a family is the "run down the beach doing backflips" type or the "snuggle close and watch birds fly by" type—as long as they are

Never Stop Shooting

I never put my camera away during a photo session—even when we are walking to a new location. You never know what little moments might pop up that may be image-worthy, like this backward glance from a little girl as her brother walked her to the next location.

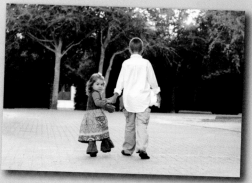

7-34. Great moments can pop up when you least expect them.

f/4.5, ¹/₂₀₀ second, ISO 1000

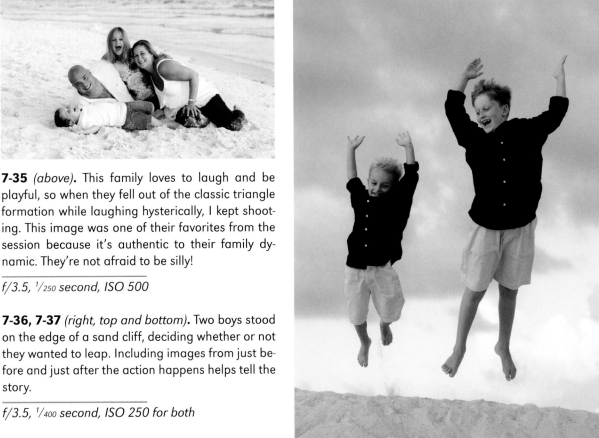

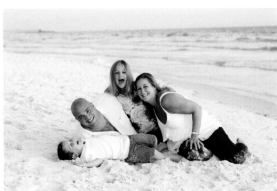

7-35 *(above)*. This family loves to laugh and be playful, so when they fell out of the classic triangle formation while laughing hysterically, I kept shooting. This image was one of their favorites from the session because it's authentic to their family dynamic. They're not afraid to be silly!

f/3.5, ¹/₂₅₀ second, ISO 500

7-36, 7-37 *(right, top and bottom)*. Two boys stood on the edge of a sand cliff, deciding whether or not they wanted to leap. Including images from just before and just after the action happens helps tell the story.

f/3.5, ¹/₄₀₀ second, ISO 250 for both

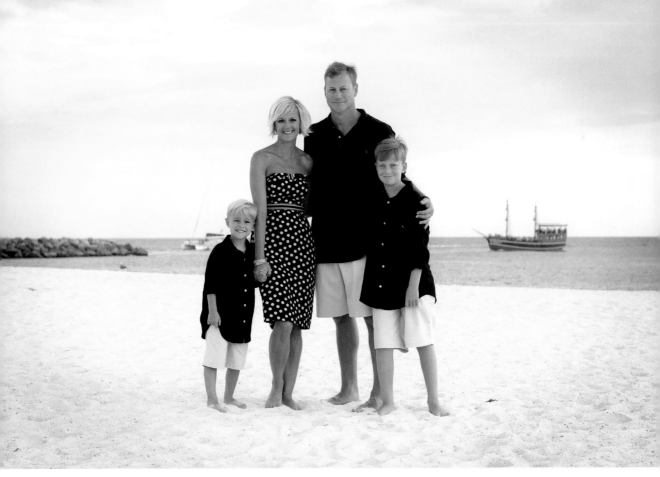

7-38. I try to execute more traditional family poses early in my sessions so that when the wiggles set in, we no longer have to stand still. This beautiful family is standing in a basic triangle shape, which is pleasing to the eye.

f/5, ¹/₂₅₀ *second*, ISO 200

relaxed and comfortable, I know that I am going to be able to provide great images.

Compose the Group, Then Try Variations. Remember the shapes you are creating with the family's positioning. Try to keep everyone on the same plane and at around the same height level to prevent one family member from sticking out oddly.

I like to offer a variety of lighting looks and backgrounds in my sessions, so I move my families around and change my camera position frequently. Depending on the time of day, I shoot some side-lit images, backlit images with and

without a reflector, and silhouettes. You can make these changes in a way that flows naturally within a session. Simply changing your camera angle can offer a completely different perspective without the subjects moving at all.

Try to get everything that you want from each location before moving on so that you don't have to go back or repeat anything.

Posing Children

Posing children can be a photographer's biggest challenge. While most adults will readily take your direction and subtly change their stance

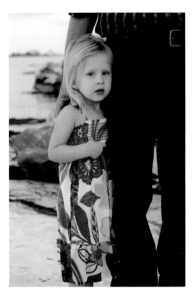

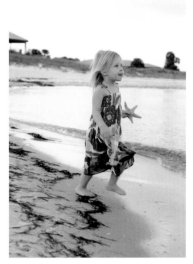

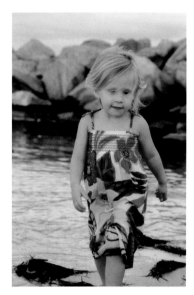

7-39 *(left)*, **7-40** *(center)*, **7-41** *(right)*. This girl was on vacation with her favorite aunt and feeling a bit homesick for Mom, so she wasn't in the mood to make friends with me. She began the session clutching her grandfather's leg, so I knew to give her some space. As soon as I turned my attention to the adults, she came out of her shell enough to play on the beach, which allowed me to get a few shots of her freely exploring the tidal pools.

7-39: f/4.5, ¹/₂₀₀ second, ISO 320
7-40: f/4.5, ¹/₂₅₀ second, ISO 200
7-41: f/4.5, ¹/₂₅₀ second, ISO 320

for the most flattering image, the children under about eight years old generally have no clue what you mean by "turn a tiny bit" or "lift your chin."

The Child's Personality. Some children are adorable little hams and already have an arsenal of poses they are ready to unleash for you. Depending on the amount of encouragement they are getting, these often become more and more exaggerated as the session goes on—but they aren't always the most flattering or natural poses for the child. Other kids must be delicate-

ly coaxed and cajoled out of their shells before they will even look your way.

Put Kids at Ease. Short portrait sessions can easily be ruined if the children you are photographing are terrified or crying, so my first priority is to make them feel comfortable with me. Tall adults can seem threatening, so I get down on their level and let them look me right in the

7-42 *(left)*, **7-43** *(right)*. These sisters were comfortable in front of the camera and enjoyed showing off their best smiles for me. Outgoing children like this can be a dream to shoot, but try to capture some authentic images (while they aren't "performing" for you) to round out your gallery.

7-42: f/4, ¹/₁₂₅ second, ISO 200
7-43: f/4, ¹/₁₂₅ second, ISO 320

Tips to Put Kids at Ease

1. Get down on their level.
2. Speak quietly at first.
3. Do or say something to make them laugh.
4. Don't touch a child or get in their face until they have made eye contact.
5. If they are clinging to a parent, back off.
6. Discuss age-appropriate television shows and characters.
7. Demonstrate the poses you want and let kids mimic you.
8. Give them time to play as you capture natural moments.

eyes. I speak quietly in the beginning so they know I am not scary, and I always try to get them to smile at me before I point my camera at them. For older children, I have a small arsenal of cheesy jokes; with younger children, I say or do something silly to make them giggle.

It is critical to be able to read children's cues and adjust your actions. If they get shy or clutch at a parent, back off immediately. If they won't make eye contact right away, don't force them or get in their face. Never touch or tickle a child who hasn't looked you in the eyes yet; wait until they give you a signal that they trust you and are willing to play. If they become anxious, allow them to get comfortable again and then try a new approach.

Know a few kid-friendly television shows or characters so you can mention them or ask questions. I have sung the entire theme song to *Thomas the Tank Engine* and *Bubble Guppies* on shoots before—and discussed in great detail which Disney princess is the best with my little models. Knowing ahead of time the ages of the children you will be photographing will help you prepare for how to approach them.

Do the Parent-Requested Poses First. Once I've gotten a few smiles and made friends with the kids, I try to get the poses the par-

7-44. This beautiful family of five created an almost perfect triangle with the gazebo behind them and their pose in the sand. Keep an eye out for shapes you can repeat within your images to make them more appealing. I placed the parents first, then had them scoop up the children at the last minute to make sure I would have enough time to get the posed shots they wanted.

f/5.6, ¹/₁₂₅ second, ISO 400

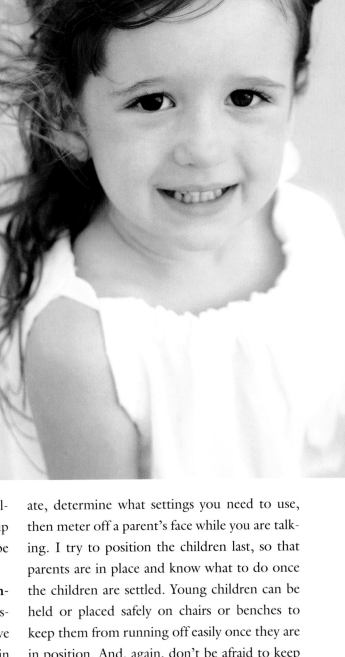

7-45, 7-46. Instead of just asking little ones to look at you, play a game of peek-a-boo. Here, I set up my camera with the appropriate settings and held it away from my face as we played. This allowed me to capture her amazing eyelashes in one shot and perfect eye contact in the second image.

f/4, ¹/₃₂₀ second, ISO 250 for both

ents have requested out of the way first. Children have a limited attention span, so any group images or slightly traditional poses need to be done *first*—before the wiggles set in.

Lock In Your Camera Settings and Concentrate on Your Subjects. The key to posing children or families with children is to have your camera settings locked in before you begin posing the family so that the second they are in position you can begin shooting with confidence. Think about the image you want to cre-

ate, determine what settings you need to use, then meter off a parent's face while you are talking. I try to position the children last, so that parents are in place and know what to do once the children are settled. Young children can be held or placed safely on chairs or benches to keep them from running off easily once they are in position. And, again, don't be afraid to keep shooting once your careful poses have yielded to more comfortable positions or more interesting activities.

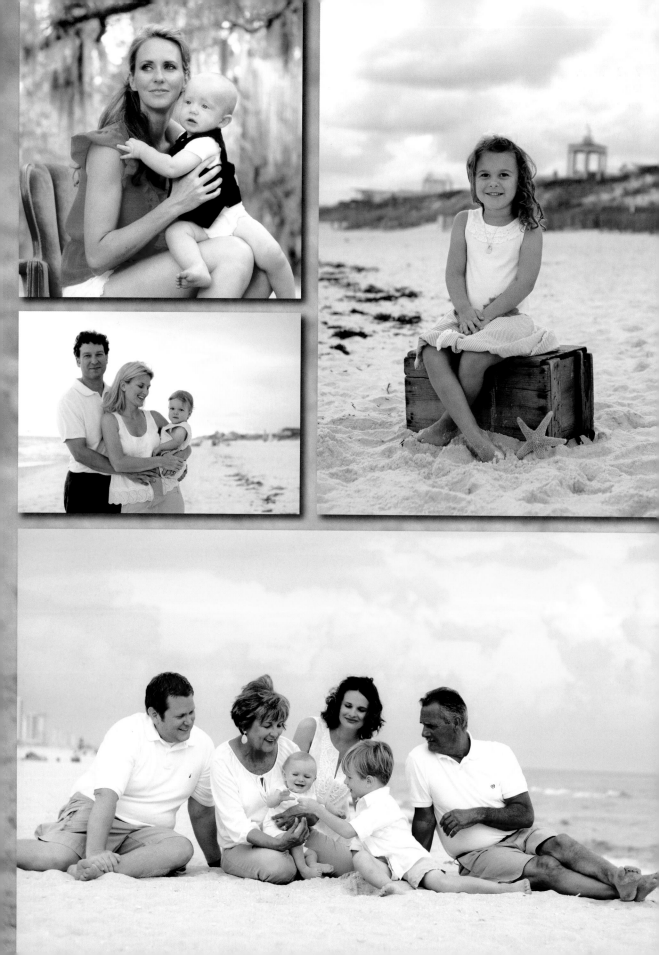

7-47 *(facing page, top left)*. This little guy was not content to stay anywhere for long, so having some interaction with Mom provided the opportunity for sweet portraits.

f/4, ¹/₁₂₅ second, ISO 400

7-48 *(facing page, middle left)*. The mother held her baby securely as the dad embraced them both. Having one or both parents hold littler ones is a natural way to keep them still for the few moments you need to get your shot.

f/3.5, ¹/₃₂₀ second, ISO 125

7-49 *(facing page, top right)*. I bring along a little crate, chair, or stool for some sessions where I know I will have younger children. Giving them something to sit on or do can give you a few minutes to capture some still portraits—as well as catch your breath.

f/4, ¹/₂₀₀ second, ISO 400

7-50 *(facing page, bottom)*. I placed this family in a classic triangle and grabbed a few images, but the sand and seashells were far more interesting than I was. Rather than stopping them, I captured a few images as they played with the boys and chatted.

f/3.2, ¹/₅₀₀ second, ISO 160

Up in the Air

A lift in the air from Mom or Dad is a trick that most babies love, even if they are fussy or crying. If you shoot from a low angle, the beautiful white clouds against a pure blue sky make a pretty backdrop for the pair (**image 7-51**). Remember to raise your shutter speed to prevent blur if you want to capture the action. I like to alternate focus between the child's face and the parent to show both sides, but if their faces are close enough together and turned sideways you can capture both.

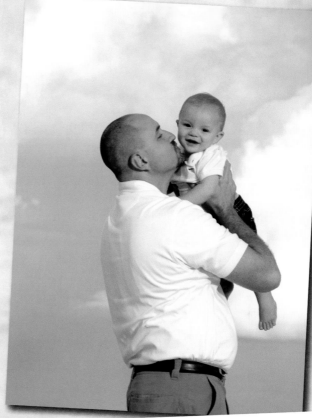

7-51 *(left)*. A baby boy gets a lift from his dad.

f/5.6, ¹/₄₀₀ second, ISO 125

7-52 *(below)*. A baby laughs as his mother plays with him in the air. The soft, hazy light made the image look timeless.

f/7.1, ¹/₂₀₀ second, ISO 250

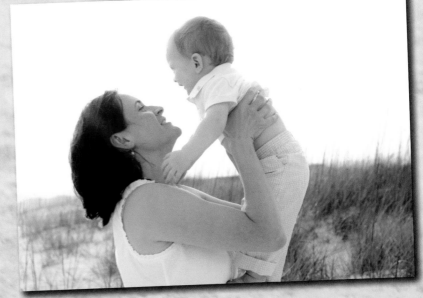

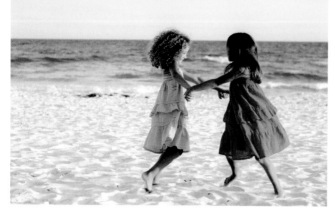

7-53 *(top left)*, **7-54** *(middle left)*. Almost all little girls love to dance at this age.

7-53: f/4, $^1/_{400}$ second, ISO 125
7-54: f/4, $^1/_{250}$ second, ISO 320

7-55 *(bottom left)*. After our family session on a hot summer evening, a thoughtful mom provided ice cream cones to her little ones.

f/4.5, $^1/_{200}$ second, ISO 320

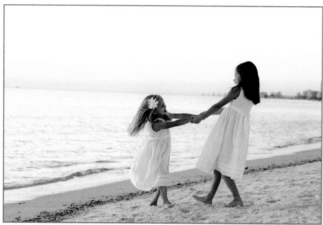

A Fascinating Prop

With a parent on either side of her for safety, I gave my little subject a starfish to play with—but it was too intriguing (top). She wouldn't look up again until I made the starfish dance over to my camera lens, where it stayed until I got my shot (bottom).

7-56, 7-57. Persistence pays off!

f/4, $^1/_{400}$ second, ISO 250

Demonstrate What You Want. Children are very visual; show them the pose you want and they will copy you. Keep it from being stiff or boring by having them tickle Mom or Dad after a few formal poses. Have a funny face competition and declare a winner. With children who are stiff, I sometimes play Simon Says and have them wiggle, jump, and touch their belly or head, leading them into the pose I want. Then I say, "Simon says 'Freeze!'" and click away.

Know When to Stop Posing. You should be able to sense when the child is almost done. Stop before you reach this point. At this time, ask them to dance, play, race against their siblings, or twirl like a ballerina with Dad. My favorite images of children are the ones from this relaxed part of the session, when the children are laughing, running, curtseying like a princess, or playing in the sand. This is a huge advantage to shooting natural light photography. You aren't stuck inside a studio or tethered to lighting equipment, so the entire location is your studio and you can achieve unlimited variety and creativity. Get down on their level—in the position you want to shoot from based on the sun and your background—then start clicking.

Have the Parents Nearby (But Out of the Way). To capture just the children alone, have Mom and Dad step off to the side instead of behind you. Well-meaning parents often direct their children to smile bigger or give directions that can go against what you've directed. That can be confusing to kids and slow your session.

Strive for Variety

Encourage your families to be dynamic and move during your session. A gallery full of images of everyone sitting is going to feel dull and lifeless. You can make suggestions about how to move or which way to turn so they are in the appropriate light, or you can let them take the lead and photograph them in a more photojournalistic manner. Let's look at some examples.

Spontaneous Moments. Image 7-58 shows a boy giving his identical twin brother a big hug during a sunset session. I had already asked the first boy to sit in this position to capture the dreamy pastel sunset behind him with the warm sun on his face when his brother decided to join the image—so even though it wasn't planned, it was still perfectly lit and beautiful.

7-58. A spontaneous hug led to a beautiful image.

f/3.5, ¹/₁₂₅ second, ISO 320

Embrace Their Ideas. The two sisters in **image 7-63** were playful and energetic. When I asked them if they wanted to try a few fun shots, they suggested dual back flips. Since both are in cheerleading and gymnastics, this was a great image that was true to their personalities, and it looks amazing.

Give Gentle Direction. In **images 7-64** and **7-65**, a picture-perfect mom and daughter giggled together—and then Mom got a kiss on the cheek. I love capturing natural interactions. To encourage this, I place them in the best light and against a complementary background, then simply let them be silly—usually by asking the

Redefine Your Idea of a "Portrait"

Toddlers are notoriously hard to photograph, but if you change your idea of what a portrait "should" look like and get down on their level, you will see tons of wonderful image opportunities. After being held for the family's traditional style portrait, we allowed the little cutie in **images 7-59** and **7-60** to explore the beach on her own terms. I sat or kneeled nearby while she played and metered off her face so I would be prepared when I saw the shots I wanted. These aren't traditional portraits in any sense of the word, but they accurately and beautifully reflect her first trip to the beach and how she experienced it. The little guys in **images 7-61** and **7-62** loved the freedom of running on the beach and playing in the sand—and leaving them to some fun time allowed me to catch images of each of them enjoying themselves.

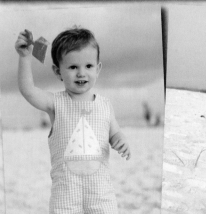

7-59 *(top left)*, **7-60** *(top right)*. If you get down on their level, you will see tons of wonderful image opportunities.

7-59: f/4, ¹/₁₂₅ second, ISO 250
7-60: f/4.5, ¹/₃₂₀ second, ISO 160

7-61 *(bottom left)*, **7-62** *(bottom right)*. These little guys loved running on the beach.

7-61: f/3.2, ¹/₂₅₀ second, ISO 200
7-62: f/4, ¹/₅₀₀ second, ISO 125

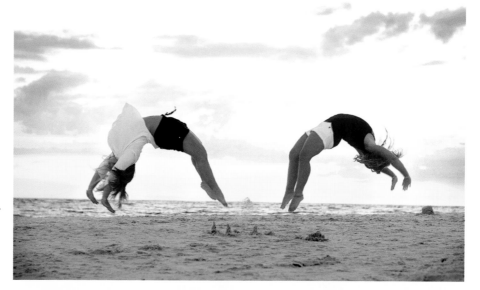

7-63. These girls are involved in cheerleading and gymnastics, so the side-by-side back flips they suggested perfectly reflected their personalities.

f/4, ¹/₄₀₀ second, ISO 320

7-64, 7-65. Simple directions are often enough to get the subjects interacting.

f/5.6, ¹/₂₅₀ second, ISO 200 for both

parent if their child is ticklish. When they react, I just keep clicking all the fun moments that follow. Giving too many directions can make a session feel forced and fake, but simple directions to get them interacting are usually enough.

Change Things Up. In quieter moments, I tend to shoot backlit images to soften the shadows and lines and create a dreamier look. When I direct a foot race full of children, I try to keep the sun behind me and have the children run straight toward me, with parents behind me on either side to give high fives and keep them from crashing into me and my camera. This makes a fun, colorful, open image and puts a bright, even light on faces to illuminate their joyful expressions without shadows to interfere.

Experiment with the poses that work best for your style and that you find to be most flattering and natural, and practice shooting on location to see how even a few small tweaks can completely change the look of your images. Being able to successfully see beautiful light in all kinds of locations opens up innumerable shooting opportunities and unlimited creativity.

8. The Business of Business

LEARNING OBJECTIVES
◈ *Set up your business and establish your brand*
◈ *Market your work through social media and blogging*
◈ *Work with clients and make sales*

Professional photography can be a rewarding career choice for those who are creative, love people, and crave independence from a set schedule and cubicle life. There is more to the business, however, than just taking amazing images. Many photographers leave the industry every year, burnt out by the grind of operating a business, working with difficult clients, and the competitive pace of social media in photography. If you want to be a lasting figure in the photography industry, you must learn the business aspect of the career and master it to the best of your ability—at least until you can hire someone else to handle that part.

Plan Costs *vs.* Income

Photography is not an expensive hobby to begin with, but the costs increase as you begin taking on clients. Equipment must be serviced and replaced, insurance and licensing fees have to be paid, supplies must be purchased, and advertising fees must be paid at regular intervals—regardless of how many clients you are bringing in as you begin.

Our industry, like so many others, also tends to have "seasons" of busy times and quiet times, depending on what genre you enter. For example, the wedding season in much of the United States is typically late March through October (the warmer-weather months). That could easily leave a photographer without jobs or income

> "To be a lasting figure in the photography industry, you must learn the business aspect of the career."

for a full *five months*, if they do not plan carefully. To compensate, many wedding photographers shoot jobs other than weddings (engagements, families, seniors, etc.) during this slower period. Others plan well enough during the "on" season to allow them to vacation and spend time with their family during the "off" season.

Regardless of how you choose to do business or what genre you decide to pursue, you must have a business plan and an organized way of executing it.

Know Your Strengths and Weaknesses

You should also take a good look at what your own strengths and weaknesses are, both in the art of photography as well as in business, so that you can capitalize on the strengths you have and learn to manage the weaker areas. Ignoring areas you dislike won't make them go away. I know that I don't enjoy the document management necessary for tax purposes—and the first year I was in business, I was *miserable* for the entire month of March as I tried to deal with it. Even though I loathed doing it, I forced myself to sit down and research a method that I knew I could maintain to keep track of expenses and write-offs. The next year was so much easier to manage that I put even more effort into keeping things orderly on a daily basis—and that continues to pay off.

Set Up Shop

Become a Real Business. Once you are ready to take on paying clients, make sure that you are doing so legally. You will need to get a permit for your business, typically in your business

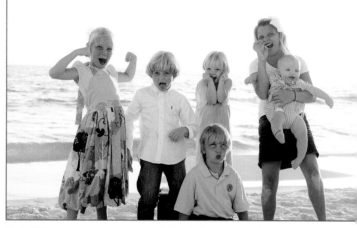

8-1. When you get a group of fun children together, all bets are off.

f/5.6, $^{1}/_{160}$ second, ISO 160

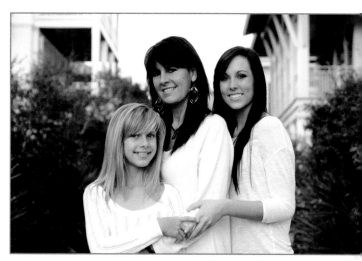

8-2. A mother appears with her two daughters in a pose that is often used for sisters or multiple generations of females. Their arms and hands intertwine to form a circle and signify the closeness of the relationship.

f/4, $^{1}/_{125}$ second, ISO 1000

name. Some states require a DBA (Doing Business As) to be filed, so make sure to check with your state laws. You'll also need a sales tax number if your state collects sales tax.

Get Insured. Get quotes on insurance for your equipment and for liability—*this is a must!* Even the most benign photo shoot can turn

into a nightmare if someone falls, equipment breaks or fails, or some part of your gear is lost or stolen. This is a "better safe than sorry" situation, and many venues want to see a certificate of insurance before they will let you begin shooting on their property. Business insurance is incredibly reasonable for the peace of mind it will provide you and your clients, so do not overlook it.

Set Up Legal Forms. Definitely do some research on legal forms before you begin taking money for jobs. You will want to have, at a minimum, your own model release allowing you the rights to use the images you take in your advertising, brochures, etc. There are many free model release examples online that you can take inspiration from, and a few Smartphone apps that make signing these right on your phone extremely simple. I use SignEasy, but there are many to choose from with different features; they are all fairly inexpensive—or even free.

Manage the Accounting. Before you take in even one dollar, you need to have an idea of how you will take care of your books. Believe me, you don't want to wait until you are a booming business to have to fix this issue. QuickBooks is simple and easy, but play around and see what works best for your workload. Even an Excel spreadsheet that will help you keep track of your income and expenditures will help tremendously when tax season rolls around in April.

Order Business Cards. Order your business cards. You can't very well go around telling people about your business without having some sort of visual representation to give them—and business cards are still the universal standard for getting contact information out there to prospective clients you meet (**image 8-3**). There are options for all budgets, from standard 3.5x2-inch cards to deluxe accordion-fold folios featuring your best work, but remember that this card will be representing your business. When you are just starting out, it may not be possible to order the nicest linen cardstock with gold embellished logos, but you do want it to look nice. I hate to judge a book by its cover, but I have been given many business cards and postcards that clearly didn't have a lot of thought or effort put into them, and it made me think twice about calling those businesses.

QUICK TIP > Check with your local government for their rules about shooting locations, necessary permits, and any fees or restrictions. Make a list of the available places so you can suggest them to clients when they call. Make like a Boy Scout and be prepared.

QUICK TIP > Whether it's business cards, fliers, blog posts, or Facebook statuses, anything you send out on behalf of your business should be *perfect*. Materials containing errors tell prospective clients that you don't care enough to double-check for tiny details. That suggests you might not be a perfectionist when it comes to their images, either.

▥ **Brand**
The collective range of colors, fonts, images, graphics, slogans, and other indicators of style and content that identify and differentiate a business within the marketplace.

You want your logo, your contact information, and maybe even an image on the card if space permits (this is an image-driven business, after all). And for heaven's sake, please *spell check!* Any business literature I receive with misspelled words goes right into my "no" pile, also known as the shredder bin. I know, I know, you're a photographer, not an English professor—but it doesn't take much to proofread the information you are handing out to the community and make sure it is perfect.

Choose Packaging Supplies. Packaging supplies are a must for presenting your customer with products and look professional, but it is easy to get crazy with this. Some people start off with nice do-it-yourself style paper envelopes and bags from craft stores, and the personal touch is certainly sweet. You want something that is easy to use, affordable, and stays in line with your brand. (For example, you probably do not want to purchase neon envelopes if you are photographing newborns—no matter how "in style" they may be.) Think about your brand when designing your packaging; the more repetitive you are with your colors, style, and level of luxury, the more that brand will speak to people and help make you memorable (**image 8-4**). At a minimum, you will want some nice image-presentation folders for in-person deliveries. Additional packaging materials will be necessary if you are going to ship your images to clients.

Establish Your Pricing. When you are just starting out, it is terribly daunting to try to put a monetary value on what you provide—and a price that you think your clients will agree to pay without fainting. However, it is imperative to figure out your pricing *before* your first pay-

8-3. Your business card is an important tool for marketing.

8-4. Packaging materials help build your brand.

ing client ever rings your phone. There are a few factors involved in this and a few ways to tackle the problem.

You can start off by simply checking out other photographers in your area. See what they are charging, then set your own fees higher or lower than theirs based on whether you think you are better or worse than they are. This is the simplest way, and it's the way that most photographers start out. However, it can be pretty misleading—especially since you typically have no insight as to what their overhead is, what they pay for products, and whether they are even making a profit.

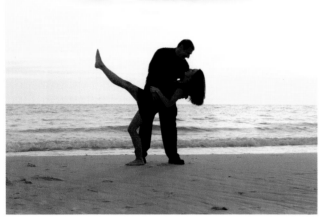

8-5. The newlyweds struck a dramatic pose while dancing on the beach near an orange sunset.

f/5, ¹/₃₂₀ second, ISO 250

8-6. This five-year-old boy hammed it up near a tidal pool in the diffused light just before sunset.

f/3.2, ¹/₅₀₀ second, ISO 320

You should take the time to figure out how much capital is required for you to do your job, and don't leave anything out. Your camera equipment, education, literature, wear and tear on your gear, cleaning supplies, marketing, and even your phone bill need to be analyzed and included. You also need to factor in your vehicle, gas, insurance, taxes, computer, Internet service, shipping supplies—the list does go on and on. Estimate as closely as you can how much you spend on these items, then estimate how many clients or shoots you will take on in a year and how many hours any given job will require. From there, you can see how much money you will actually be making in an hour. If need be, you can adjust your expenses, your fees, or your number of clients to adjust that hourly rate. This is quite a bit of work, but there are lots of helpful spreadsheets and workbooks online that can make it less of a chore.

Of course, you still have to make sure that you are priced reasonably for the service you will provide to your client. If you charge three times as much as a photographer down the street whose images look just as good as yours, it doesn't take an accountant to see that you are going to have a harder time getting clients in the door than they are. You definitely don't want to undervalue yourself or your product, but making sure that you are offering a product and overall experience that is in line with your fees will help keep the clients calling.

Spread the Word

As you acquire more images that represent you and your business, you need to share them with the world.

Social Media. Social media (Facebook, Google+, Twitter, Instagram, etc.) can be a huge blessing. With minimal effort, you can reach many people who will hopefully become clients. When your fans "like" your images, those shots will potentially reach many of their friends as well, further widening your circle. Sharing images of clients and allowing them to tag themselves will not only be a bonus for your client (almost everyone wants to share their

images with friends and family, and social media is the easiest way) but as a bonus for you, it will put your product in front of other potential clients. Remember to watermark any images you share online—not only to help protect your images from theft but also to announce to the online world that you created them.

In addition to images, on most social websites you also can share things about yourself that let prospective clients get to know you—but be careful. You should avoid sharing anything potentially controversial on your business page; religious topics, political opinions, and even parenting styles can be hot-button issues for some people. Unless you are comfortable with people judging your business based on your personal opinions, it's best to leave those on your private profile instead. On your business page, you can engage customers by running contests or giveaways, conducting polls, and posting interesting articles that you think your client base will enjoy.

Blogging. Blogging is another way photographers stay connected with fans and get their work seen. Clients love when you share images and stories from their sessions, and prospective clients can take a peek at your personality through these posts, giving them a glimpse at how much fun their own session with you might be. Your blog is also a good place to share tips on wardrobe selection, locations you find interesting and want to shoot in, and even personal stories about yourself or your family—you choose how personal you want to be in this public outlet. Make sure you allow linking to Pinterest if you want blog visitors to be able to "pin" your pictures or stories to share among their friends (with a link back to your site, of course).

"You should avoid sharing anything potentially controversial on your business page."

Make Regular Updates. Many photographers swear that Facebook is their best marketing tool; others claim that blogging religiously is what gets clients in the door. Whatever you select, make sure it is something you can do *on a regular basis* so that people consistently see new images and information from you and know that you are working. It's often the case that the business we think of first is the one that makes itself known the loudest, so toot your own horn. Share what you've done, what you're excited about, upcoming sessions you have planned,

8-7. Your online presence should give clients a pleasing, consistent impression of you and your business.

8-8. A family trio in a perfectly balanced pose.

f/2.2, ¹/₅₀₀ _second, ISO 200_

8-9. Different fonts each evoke a different emotional response. How do you want to be perceived?

and make it memorable. Some Facebook engineers claim that there are over 200 million images uploaded per day, which means you need to stand out to keep reaching your fans.

Build Your Brand

Consistent branding is an important aspect of your business. It can greatly affect whether or not clients select you as their photographer.

Stand Out. Clients are inundated with choices. How do they decide? Think about this:

just about anyone can make a cheeseburger, but hungry people tend to head toward icons they know and trust if they want a guaranteed experience. Good branding can set you apart from the photographer down the street if people remember it and identify your work with it.

Choose Your Logo. Your logo can be as simple as your name in a font you like, but remember that even fonts evoke an emotional response and contribute to your brand (**image 8-9**). If you want a more graphic look, make sure your design skills are up to par or hire this job out. Even people who are not in the arts can spot bad graphic design. Clumsy design will _not_ send the message that you are a polished professional. Your logo is your "billboard," so it needs to be in line with your work as a professional.

Pick the Right Business Name. Before naming your business, decide on a professional direction. If you name your business "Giggles and Dimples" and adorn your site with rainbows and butterflies, then decide that you'd rather shoot boudoir, you may have to start all over with your brand. In the beginning, brand yourself loosely in the direction you think you are headed so you have room to grow as you explore. It's definitely okay to upgrade your site, your logo, and your watermark as you evolve— but most photographers do not do well if they have to start over from scratch with a whole new brand, look, and feel to their online presence.

Consider Your Target Client. Take some time to think of your target client. What age group do they fall into? Are they married with children? Are they the corporate, jet-setting type? What income bracket do they fall into? Do they want formal, perfect images or whimsi-

cal shots? Once you have a general idea of who your audience should be, take a look at some of the brands this group of people would purchase. Are the logos classic and modern or organic and fun? Women who shop at luxury stores like Gucci or Versace will likely not look to hire a photographer whose style looks silly or amateurish. You can speak to your client base simply through your branding and tell them about yourself without ever actually saying a word. I like simple, clean websites that focus solely on my images, which are colorful and fun. Other people are more impressed by websites with all the bells and whistles, full blogs, rolling ticker-tape announcements, and new videos uploaded every week. You have to find what works best for *you* and what *you* can manage.

Make the Sales

Once you've gotten some interest in your work, you need to make the transition to the business level in order to make money.

A Service-Based Industry. A successful photography business is not just about the images. You do, of course, need to know how to produce a quality product; you also have to be good with people. In fact, the most successful photographers are the ones who realize that the field is less *product*-based and more *service*-based than it appears. You don't have to be a social butterfly to be the kind of "good with people" necessary for sales. You just have to know your client and be able to adapt to their comfort zone while selling your services and tooting your own horn (or hiring someone to toot for you) online. Since the majority of your sales will begin as phone calls, we will start there.

Hone Your Phone Skills. Knowing how to "cold read" a person over the phone is amazingly useful—not just in business, but in every situation. How many times has your mom (or significant other) called you when feeling upset—only to get even *more* upset when you didn't pick up on their unstated emotion? To them, it's as obvious as the sun that they are angry or hurt, but without the benefit of facial expressions or body language, it isn't always clear over the phone lines what their tone of voice should imply to you as the listener.

> ■ **Cold Read**
> Indirectly gathering information about a person by analyzing subtle signals (fashion, gender, body language, manner of speech, etc.).

Hopefully, none of your clients will begin their first contact with you in an upset state, but you still need to be able to "cold read" their personality and possibly even mood in order to

8-10. This girl giggled as she rode her favorite pony at the local carousel. The colorful image aptly describes this three-year-old beauty.

f/4, ¹/₂₀₀ second, ISO 125

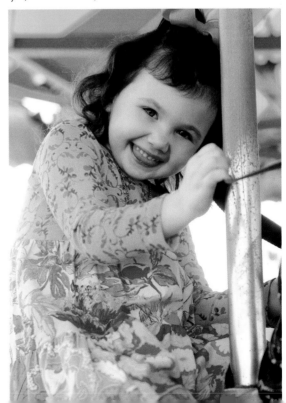

Four Basic Sales Categories

While there are obviously exceptions to every rule, most people fit into one of four extremely basic sales categories: analytical, amiable, expressive, or dominant. Callers will usually give you clues about which category they might fit into in the very first sentence they speak. The key is to listen and be able to adapt quickly to whichever category you feel suits them—and be prepared to switch gears quickly if you should guess wrong.

8-11. Four personality categories differentiated by assertiveness relative to responsiveness.

adjust your words to keep them interested in you. At this point, I might have lost you, but stay with me. Of course you can just be polite and professional and answer all of their questions about your work and fees—and they may even book you. But with the increasing number of photographers in every semi-metropolitan area and more and more clients getting savvy about shopping around for the one photographer who seems like the best fit for them, you want to stand out from the very first contact.

Mirroring the caller's tone is a useful way to begin reading them. If they are loud and speak very quickly, you should try to speak slightly less loudly and quickly so as not to overpower them. If they are soft-spoken and take their time with words, you should know instinctively to tone your own speech down to match theirs. Don't try to mimic accents, but you *can* repeat words you hear them use. This not only lets the caller know you are listening to them, it helps them feel more connected with you since you are literally speaking the same language.

Know Your Business. Having the answers to as many questions as possible will help your interactions with clients go smoothly. Ask yourself what questions a potential client might have and know the answers so you can reply immediately. This will increase the potential customer's confidence in you and lead to more bookings.

Photographers who fumble for answers to routine questions seem like unprofessional, disorganized novices, so consider having a short script typed out. Practice this before taking business calls and work on getting comfortable with your professional tone and with speaking about your business. It sounds silly, but if you have never worked in sales before it may feel unnatural to speak about yourself or your business in a way that entices clients to book with you. Clients enjoy people they feel comfortable speaking with naturally, so you don't want to sound stiff or forced. Most people don't respond favorably to the pressure of a "sales pitch," but a bit of polish goes a long way toward building value in you and your business.

1. Analytic (Thinker)

The Client: Analytic clients are organized, deliberate, and cautious. They like things to be logical and controlled. Analytic clients have researched everyone in a 20-mile radius and have made lists of everyone they like. If they are calling you, it's because you've made the initial cut. They will want facts about your work, sessions, and availability. They will want to know your contingency plan in case of rain and if you have backup shooters and equipment. They may ask questions to which they already know the answer, testing your credibility to see if they can trust you. *Typical speech:* moderate to slow, in order to methodically learn all facts.

Your Response: Know your stuff. I have a cheat sheet of sunset times by my computer, and I keep a log book of the best locations close at hand. I keep track of entrance fees and closing times, and have maps and driving directions I can refer to and e-mail to help someone make a decision. Be confident, so they know they can trust your answers—but make sure that you are answering *correctly.* If you are unable to answer a question immediately, be up front and say something along the lines of, "I'm not 100 percent sure of the answer right now, so I'd like to verify before I answer you." They will always appreciate your honesty and effort.

2. Amiable (Facilitator)

The Client: Amiable clients are easygoing, trusting, and friendly. They don't like to be bogged down with a lot of details and are relaxed and considerate. They tend to think everything is going to work out just fine. Amiable clients want to agree with you as much as possible and don't enjoy being pressured, so start off by building a friendly relationship with them. *Typical speech:* Soft, friendly, not too fast.

Your Response: Go slowly and show them that you care. Ask their spouse's name and the names of their children—and write them down for reference; this small thing will mean a lot to them. Share information about yourself or your family, but use it to steer the conversation back to them. Build the perceived value of your business by emphasizing the personal connection and customer service you will provide. Give them time to think things through and keep things relaxed.

3. Expressive (Persuader)

The Client: Expressive clients are energetic, dramatic, and talkative. They are impulsive and have a lot of ideas, but don't always follow them through. They are confident and enthusiastic. They are usually very persuasive and likable but tend to have short attention spans. They enjoy recognition for themselves or things they have contributed to and like to talk about their opinions. *Typical speech:* Fast and loud, exaggerated.

Your Response: Speak casually and ask open-ended questions. Listen for things they are proud of and compliment them on those to make them feel important. Build value by emphasizing how unique your services and images are—and how appealing they are to others. Mention any awards, or that many clients return year after year, or that clients from their school/church hire you all the time. They like to keep up with (or be a step ahead of) their friends, so tell them about any new product and that they will be the first to be able to order it.

4. Dominant (Controller)

The Client: Dominant clients are direct and assertive. They talk quickly, make decisions quickly, and are focused on results. This type of client will rarely make small talk. They will begin the conversation telling what they want out of a session with you. They aren't necessarily unfriendly, they are just extremely driven to complete their task, which in this case is finding and scheduling a photo session. You are likely not the only person they are calling; they have a list. They want to find the best in the business for the best price they can manage, and they want to be in charge of as much as possible. *Typical speech:* Quick and loud, slightly demanding.

Your Response: Get to the point. Don't linger over the story of how you became a photographer (as adorable as it may be); don't gush for long minutes over the beauty of their chosen location. Answer each question succinctly and be ready for the next one. Always let them lead the conversation—or at least make them feel as though they are. Try to avoid being overly enthusiastic, as it will seem fake to them. Instead, be businesslike and efficient. Listen for any concerns they may have and address those issues quickly to keep them feeling comfortable with you. Sell your services based on the quality of the results and the specific products you offer—especially those they have shown an interest in.

What Clients Want to Know

1. Your availability (have an updated calendar handy when answering calls).
2. General rates and pricing information.
3. What you include in your rates or packaging.
4. How long sessions are.
5. Your experience.
6. Your location information and directions.

When I decided to launch my photography business full time, my husband, who has been in sales for twenty years, sat me down with a list of reading material and made me practice speaking about my business, my products, and my services. I was reluctant at first, but quickly saw the advantages of practicing to avoid long, awkward pauses and fumbling for answers. If you don't have a friend or a spouse you can practice with, record yourself to hear the areas you should work on.

In-Person Meetings. If you need to meet with your clients face-to-face before your session (which is typical, especially with wedding clients), make sure you are friendly and open—and remember what personality type you feel they fit into from your initial phone conversa-

tions. Knowing how to approach them from the beginning of your in-person meeting will not only help your meeting go more smoothly, it will help them feel more comfortable quickly, since you should be responding the same way you did over the phone.

Make personal notes about their session, including anything special they may want or have mentioned. Is the session a gift for Mom? Is it the first time the family has been together in five years? Is a family member soon to be deployed with the military? Good notes not only keep you organized but show you are paying attention to your clients as individuals—and that you care about them and what they want. And if the session is a Mother's Day gift, don't just toss out a "Happy Mother's Day" to the mom; make sure you get a great image of her with her kids, and one of the special mom by herself. As specifically as you are able based on what you've learned about them, think about what the client might like and reflect that in your work. Even before you turn on your creative brain to envision what you'll shoot, you can think ahead to the sale and hypothesize about what kinds of images they might find the most meaningful. You'll want to be sure to offer those images in their gallery.

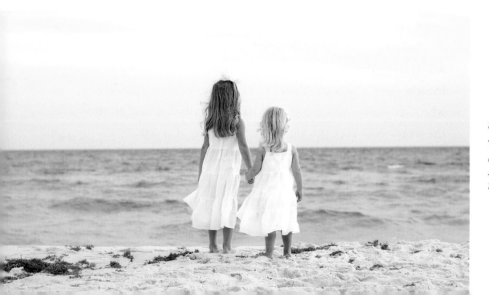

8-12. Bright sunlight turned the Gulf of Mexico shades of emerald green.

f/4, 1/320 second, ISO 320

Final Thoughts

*R*emember that everything you put your name on represents you and your business. In today's ever-shrinking world of technology, you never know where your next referral may be coming from or who may be watching your work. No matter what the subject matter, you should strive to make sure that your images are a reflection of what you want your business to be and nothing else. There are many photographers out there for clients to choose from, and the only thing setting you apart from the rest is *you*. Be genuine—in your art, your branding, and with your clients—and you can't go wrong.

I have met so many amazing people through my business, many of whom I am now lucky enough to count as friends. I love being able to witness the true emotions of a family—the pride of new (and old!) moms and dads, the serenity of grandparents who have been married for decades, the way toddlers adore their parents, the amusement between teasing siblings. Seeing so much love and hope in so many different families makes me feel grateful to be a part of it.

I joke that I have the best job in the world because I get to watch the sun set every evening on a perfect white beach with friends—and that's true. But I feel the same way regardless of where or what I am shooting. I truly adore being able to show the world how I see things, one small picture at a time.

"I truly adore being able to show the world how I see things, one small picture at a time."

Index